Looking at Indian Art of the Northwest Coast
Hilary Stewart

Looking
at Indian
Art *of the*
Northwest Coast

Hilary Stewart

Douglas & McIntyre
Vancouver/Toronto

University of Washington Press
Seattle

Published in Canada by
Douglas & McIntyre
1615 Venables Street
Vancouver, British Columbia V5L 2H1

95 96 97 98 99 19 18 17 16 15

All photographs are by the author, with the exception of the following: *American Museum of Natural History:* 4. *British Columbia Provincial Museum (G.T. Emmons):* 5. *Thomas Burke Memorial Washington State Museum, Seattle:* 61. *Joe Huber:* 109. *Hans Kirchner:* 133. *Museum of Anthropology, University of British Columbia:* 65, 149. *National Museum of Man, Ottawa:* 148. *Royal Bank of Canada:* 56. *Vancouver Centennial Museum:* 2, 3, 38, 111, 150, 151, 155. *Vancouver Sun:* 104, 154.

Designed by Robert Bringhurst. Typeset in Mergenthaler Palatino by Zenith Graphics Limited, Vancouver. Printed and bound in Canada by D.W. Friesen & Sons Ltd.

Printed on acid-free paper ∞

Canadian Cataloguing in Publication Data:

Stewart, Hilary, 1924-
 Looking at Indian art of the Northwest Coast

 Bibliography: p.
 ISBN 0-88894-229-X

 1. Indians of North America—Northwest
Coast of North America—Art. 2. Indians
of North America—British Columbia—Art.
I. Title.
E78.N78S78 709′.01′1 C79-091029-2

Published simultaneously in the United States of
America by the University of Washington Press,
P.O. Box 50096, Seattle, Washington 984145-5096

Library of Congress Cataloging in Publication Data:

Stewart, Hilary.
 Looking at Indian art of the Northwest Coast

 1. Indians of North America—Northwest coast of
North America—Art. 2. Prints, Indian—Northwest coast
of North America. I. Title.
E78. N78S764 769′.9795 78-73988
ISBN 0-295-95645-3

to Bill

Acknowledgements

The idea for this book grew out of the need for it. The initial concept was nurtured and encouraged by people recognizing the need, and was wholeheartedly supported by the Indian artists who are so much a part of these pages.

Many people have contributed their time and knowledge to make this book possible and enhance the contents. I would like to extend my sincere thanks to Lia Grundle, Executive Marketing Services, and Bud Mintz, Vancouver Community College, who helped me in locating some of the artists, as did Peggy Martin, Director, Children of the Raven Gallery, who also suggested the book's title.

I am indebted to Margaret Blackman, Joe David, Bill Holm, Allen Hoover, Barbara Moon, Susan Moogh, Tim Paul and Bill Reid for their helpful contributions pertaining to the artistic, social, mythical and spiritual significance of the fauna and design of the Northwest Coast cultures.

My thanks to those at the following museums for their kind assistance in meeting my photographic requirements: American Museum of Natural History, New York; British Columbia Provincial Museum, Victoria, B.C.; Museum of Anthropology, University of British Columbia, Vancouver, B.C.; National Museum of Man, Ottawa; Portland Art Museum, Portland, Oregon; Thomas Burke Memorial Washington State Museum, Seattle; Vancouver Centennial Museum, Vancouver, B.C. Thanks also to the Royal Bank of Canada for permission to use its emblem, and to Mrs. W. H. Cross, Sidney, B.C., for kindly allowing me to use a photo of the goat horn spoon from her collection.

Throughout this volume I have made much use of Indian artists' graphic designs, many of which are now out of print and have become collectors' items. I wish to thank the following people and companies who kindly allowed me the free use of their collections and who gave generously of their time to assist me:

Bill Ellis of Canadian Native Prints Ltd., Vancouver, whose close and personal interest in my work was largely responsible for initiating this book, and whose frequent help and support I have greatly appreciated for many years; Leona Latimer, Manager, Centennial Museum and Planetarium Association Gift Shop, Vancouver; Gordon McKee of North Vancouver; Sidney J.

Orack of Images for a Canadian Heritage; Vin Rickard of Open Pacific Graphics, Victoria; Larry Rosso of N.W. Screencraft Enterprises Ltd., Vancouver.

Many people have made a great number of prints available to me, and so I have been able to select a broad range of subjects and styles from over thirty artists, although there were some I did not reach. Prints were chosen that would best serve the purposes of this book, but regrettably many excellent examples could not be included for technical reasons or lack of space. The artists' enthusiasm for the book and their response to my request for permission to use their work has been heartwarming, and to these talented men and women I extend my warm and sincere thanks:

Frank Charlie (Kwya Tseeck Tchuss Miyuh), Beau Dick, Freda Diesing, Joe David, Robert Davidson, Amos Dawson (Chief Ne-Ka-Penkum), Walter Harris, Sharon Hitchcock, Calvin Hunt, Richard Hunt, Tony Hunt, Hupquatchew (Ron Hamilton), Phil Janzé, Gerry Marks, Ken Mowatt, Earl Muldoe, Tim Paul, Larry Rosso (Sisakolas), Bill Reid, Ron Sebastian, Robert Sebastian, Art Sterritt (Mixanxa), Neil Sterritt, Vernon Stephens, Russell Smith (Awasatlas), Jerry Smith, Norman Tait, Art Thompson, Roy Henry Vickers, Clarence Wells, Don Yeomans.

I am also indebted to the artists who kindly read over the pages concerning the regional art styles, and offered criticism and suggestions for greater accuracy. For their help I wish to thank Joe David (West Coast), Robert Davidson (Haida), Tony Hunt (Kwagiutl), Della Kew (Coast Salish), and Art Sterritt and the 'Ksan artists ('Ksan).

Particular thanks must go to Bill Holm, curator of Northwest Coast Indian Art at the Thomas Burke Memorial Washington State Museum, Seattle, for reading through the entire manuscript. As the foremost authority on the subject of this book, he has given invaluable comments and corrections, and I have very much appreciated the interest he has taken in my work.

One of my earliest recollections of becoming interested in the painted two-dimensional art of the Northwest Coast Indians and their portrayal of faunal and mythical creatures is a lecture series I attended in 1968. The lecturer was Wilson Duff, professor of anthropology at the University of British Columbia. He strove always to understand the inner, deeper meaning of Northwest Coast art, and in subsequent years and until his death in 1976 I continued to draw from his vast fund of knowledge whenever we discussed the subject. For the years of enrichment he gave to the interest he initially fostered in me, I am indeed thankful.

Contents

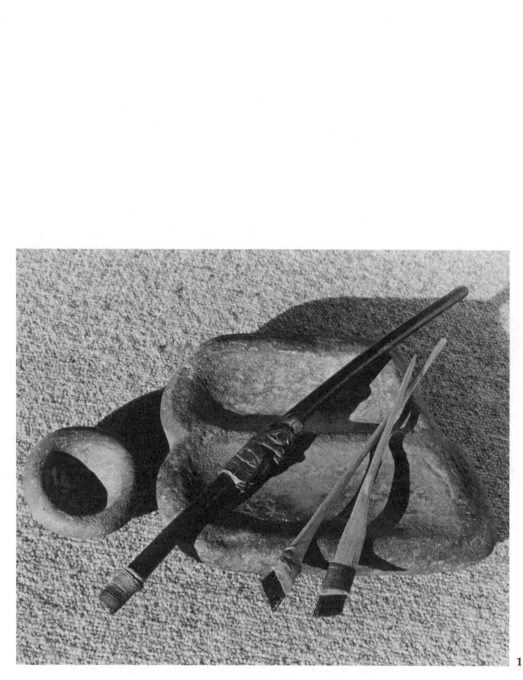

1 Stone palettes still hold the residue of red and orange pigments once applied with brushes of bristle set into split cedar handles; all are Kwagiutl. The large brush with a bear carved on the handle is Haida. Museum of Anthropology, University of British Columbia.

10

Introduction

Unique in the world of so-called "primitive art," the full, rich range of the art of North America's Northwest Coast Indians has only recently begun to take a prominent place in the museum exhibitions and art galleries of the world. In the market place, original works by native artists and craftspeople have become highly prized collectors' items commanding substantial sums of money.

The intention of this book is to give the reader an appreciation of the two-dimensional art of the Northwest Coast. After first examining the individual components, and understanding how they are combined to create faunal designs, the reader will learn how to identify the subject, whether it is depicted in stylized realism or re-arranged into near abstraction.

Because the book is concerned with the graphic art, illustrations are mainly taken from painted household and ceremonial items and contemporary silkscreen designs, but many of the symbols of identification can be found in carved works also, and a few examples are given.

In his definitive analysis of Northwest Coast art published in 1965, Bill Holm introduced concise terms for the basic shapes and practices within the art: for example, where writers had previously tried to describe the "round-cornered rectangle" and the "squared-off oval," Holm used the single word *ovoid*. This nomenclature for the basic components, around which the entire art is formed, has become firmly established in the vocabulary of the art. The ovoid and other shapes will be reviewed as the first step in understanding the organization of the design fields.

Contemporary art of the Northwest Coast Indians, particularly in the field of print making, has evolved through many changes in a short period. The past decade has been a time of cultural searching for many of the artists who were caught up in a rather general Northwest Coast style (based largely on northern art) and found that they needed to define and establish a style that was essentially of their own people with roots in their own traditions. Through their researches, and with the help of the elders of their villages, the artists have succeeded in determining their own cultural distinctions, and in so doing have made us aware of their regional differences.

Considered six ethnographically distinct peoples, the Coast Salish, the West Coast people (or "Nootka"), the Kwagiutl, the

Tsimshian, the Haida and the Tlingit shared cultural, economic and environmental backgrounds. They were all hunters and gatherers who lived along the river valleys and coastal waters of the Pacific Northwest, skillfully using the abundant resources of river, sea and forest. In this book's final chapter the reader will gain an idea of how to distinguish the art of the different cultural areas by looking at examples of design—mainly contemporary prints. I have not included the relatively small group of the Bella Coola people; although in sculpture a clear distinction exists between their style and that of other groups, it is less distinctive in painted form, and none of the people of that region are, as yet, working in two-dimensional design.

Along with most of the mythical and crest figures I have included a selection of legends and myths pertaining to them. In their original form many of these are lengthy and complex, and some make fascinating reading, but as this is not a book of legends I have abbreviated them considerably.

One of the exciting things about print making is the possibility it offers for experimentation; many artists have grasped the medium to pursue new design ideas or use it in new ways. Robert Davidson, an eminent Haida artist and one of the earliest of the silkscreen print makers, has said: "The only way tradition can be carried on is to keep inventing new things."

The "new thing" in two-dimensional art—silkscreened prints in signed, limited editions—is now a firmly established tradition on the Northwest Coast. The next decade will no doubt see fresh trends in print making. With the Indian artists' feel for wood and their skill in carving it, possibly the next "new thing" could be native designs in woodcuts.

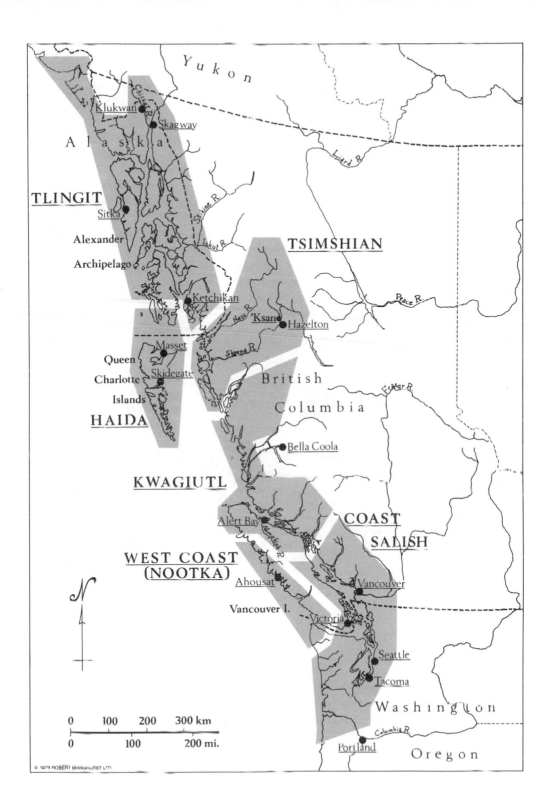

Y u k o n

Klukwan
Skagway

A l a s k a

Liard R.

TLINGIT

Sitka

Alexander

Archipelago

Stikine R.

Taku R.

TSIMSHIAN

Peace R.

Ketchikan

Nass R.

'Ksan
Hazelton

Masset

Skeena R.

Queen

Charlotte

Islands

Skidegate

B r i t i s h

C o l u m b i a

Fraser R.

HAIDA

Bella Coola

KWAGIUTL

Alert Bay

Nimkish R.

COAST

SALISH

WEST COAST
(NOOTKA)

Ahousat

Vancouver I.

Vancouver

Victoria

Seattle

Tacoma

W a s h i n g t o n

0 100 200 300 km

0 100 200 mi.

Columbia R.

Portland

O r e g o n

© 1979 ROBERT BRINGHURST LTD.

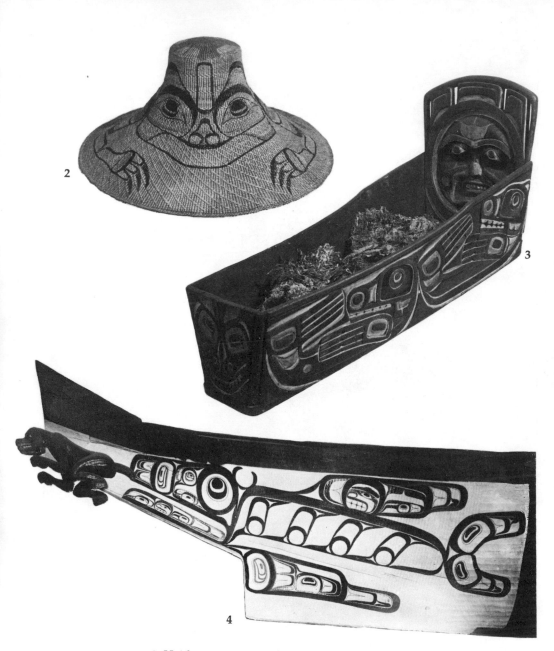

2 Haida spruce root hat with bear design. Vancouver Centennial Museum.

3 Kwagiutl cradle, carved and painted with the family crests of the child. At the foot is a bear; at the head, a moon. Two sea lions are on one side, a killer whale on the other. Vancouver Centennial Museum.

4 Although typically Haida in shape, this canoe was made by the Kwagiutl. At the bow a carved animal forms the figurehead, and painted killer whales adorn both sides. American Museum of Natural History, New York.

1 / The Two-dimensional Art

Lightning snakes, whale-eating thunderbirds, two-headed sea serpents and animals that transform themselves into people are among the many colourful creatures that have adorned the household as well as ceremonial possessions of the Northwest Coast Indians. The dynamic imagery of these peoples, expressed in a style as rhythmic and flowing as it is complex, has created one of the world's most remarkable art traditions. It is an art with vitality and profound meaning for those of its culture.

In the past, the social and spiritual order of the Indians was visually confirmed through their art. It was seen in totem poles and house posts which bore the crests of their owners; in elaborate masks and intricately carved goat horn spoons; in tobacco mortars wrought from stone, and delicate pendants made from bone or antler; in magnificent ermine-trimmed headdresses, and spindle whorls enriched with symbolic carving on both sides. Excelling in three-dimensional sculpture, Indian artists also worked in flat design, using brush and pigment to enhance many possessions. Most of these paintings portrayed the crests of their owners, often declaring the owner's lineage, wealth and status. Some had mythical or spiritual meanings. Probably very few had ornamental value alone, although a great love of decoration is shown by its abundant use.

Painting embellished canoes, paddles, finely woven hats and baskets, dishes, spoons, boxes, drums, rattles, chiefs' seats, ceremonial garments, dance screens and shamans' charms. Some of the finest examples of graphic art are to be seen on the painted bentwood boxes and chests used for storing chiefs' regalia and for important burials. The smooth, rectangular shape of the box sides, vertical or horizontal, once provided the "canvas" for the artist's brush.

The colours most frequently used were red and black, although a blue-green and sometimes a yellow were also used in some areas. The red was made from red ochre, a hard clay-like mineral, and probably from hematite also, while black was derived from charcoal, graphite or lignite. These materials were ground to a powder and mixed with a binding agent. For the latter, dried salmon eggs were chewed in shredded cedar bark, which retained the membranous parts of the egg while

allowing the oil to mix with saliva. The resulting liquid was spat into a stone palette or paint dish and mixed with the powdered pigment to the right consistency. Later, the availability of commercial paints gave rise to experimentation with other colours.

Brushes of several sizes were made of animal hair—often porcupine—lashed to the squared end of a round wooden handle and cut off at an angle. As with the carver's knife, the brush was drawn towards the body, not away. The artist used the edge of the brush for outlines, and the width of it for filling in. Templates, cut from hide or cedar bark, were used as a guide to drawing certain shapes, and to ensure uniformity in a symmetrical design.

The making and painting of household and ceremonial items was largely abandoned as the new culture spread and took hold in the nineteenth century. Missionaries and school-teachers worked hard to ensure that old ways were forgotten, and the banning of the potlatch by federal law struck the final and most damaging blow. But with the renaissance of native Indian arts in the late 1960s, and its rapid expansion through the 1970s, artists discovered another medium in which to express their talents, and through it produced a household item unknown in the old days. The medium was silkscreen printing—and the household item was the picture to hang on the wall. Family crests and depictions of mythical creatures of legend were now being multiply reproduced on paper. Public appreciation of native art was increasing and a few artists began to make a living from the sales of their prints and other works. And as a new awareness of the old culture's inner strength surged along the coast like a flood tide, the revival of potlatches, dancing and ceremonials again demanded designs and regalia from the artists, and this activity inspired many young people to pursue creative arts. Two-dimensional designs of family crests were required for a growing number of button blankets; painted dance screens were revived; dance aprons, drums and rattles were in demand. The silkscreen print became a gift item at the potlatch, and even invitations to attend the ceremonial event were specially designed and printed. Two-dimensional art was back—and thriving.

Northwest Coast art owes its structure to a general system of design principles. Depending on how these are used, the crest or motif being portrayed can vary from realistic and easily recognizable to involved and somewhat difficult to figure out—or the identity of the figure can become totally abstracted through the rearrangement of its anatomical parts. Examining the individual elements largely used in the art form, and

16

recognizing the ways in which those elements are put together, enables us to grasp the structure of the art. We may not be able to fully comprehend the inner meaning of the images, but in learning to identify them we can appreciate the imaginative qualities of the artists and respect the great cultures that produced them.

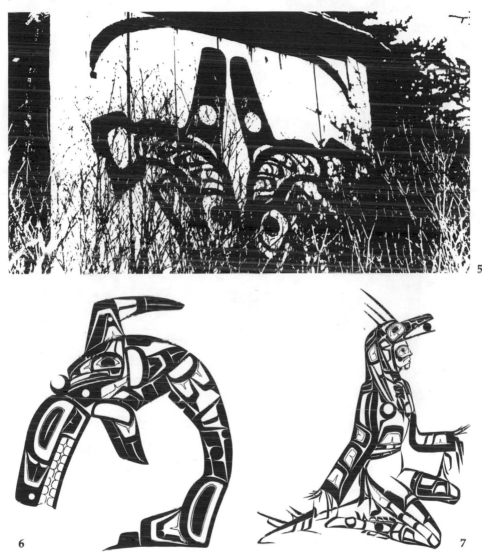

5 Killer whale design painted on a grave house at Sitka, Alaska. c. 1888-89. (Tlingit)

6 *Killer Whale and Grouse,* by Ron Sebastian. ('Ksan)

7 *The Dance of the Raven by the Gitksan Dancer,* by Vernon Stephens. ('Ksan)

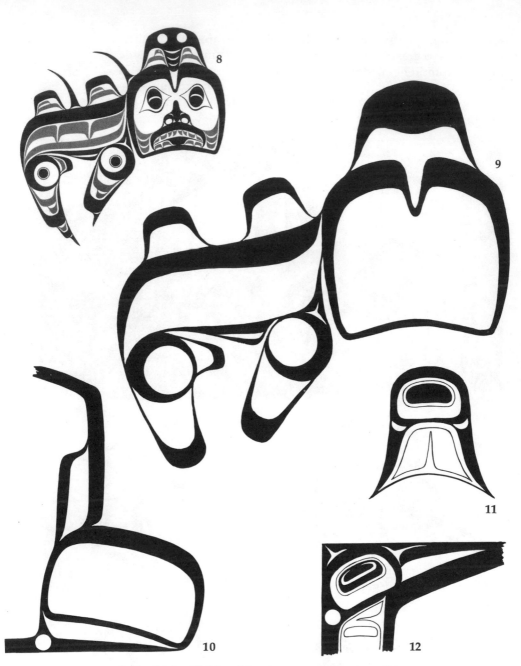

8 *Dogfish* by Phil Janzé has its general structure delineated by the form line. ('Ksan)

9 The same dogfish design, in form line only.

10 Detail of a form line, showing how each portion of the line changes in thickness and direction and how it tapers at junctions.

11, 12 Details from two designs showing the T and Y shape and the circle and crescent.

2 / The Basic Components

Form Line

The two basic colours of Northwest Coast graphic art are black and red. Black, the primary colour, is mainly used for the form line, a strong contoured line which structures the design and clarifies the anatomy of the subject by defining the head, wings, joints, tail, etc. Red, the secondary colour, is generally reserved for elements of secondary importance. When occasionally an artist reverses this order, the red form line still creates the framework of the design.

Northern artists employ a blue-green as the tertiary colour in many painted and carved designs, and this can occasionally be found in prints also. Sometimes even a fourth colour is added to silkscreen prints for brilliancy, usually by Kwagiutl artists, for whom a variety of colour is traditional.

In the northern art style particularly, the form lines curve, connect and flow continuously, and where a heavy line meets a curved one, a simple device is used to avoid a thick, clumsy look. The artist adds a negative shape in the form of a crescent, a T or a Y at the junction; this maintains the outline of the curve and gives relief to the solid thickness. Where two heavy lines meet, or in any other area where the mass of colour is unbroken, the negative relief may be a circle. One authority has described the negative circle as a crescent which has "fallen in on itself."

The form line changes constantly, in both thickness and direction. In spite of this undulating movement, the tautness of the linear structure and the sudden turn of the lines prevent the design from having a runaway, swirling appearance.

Ovoid

Probably the single most characteristic shape used in this art is the rounded rectangle termed the *ovoid*. A well-made classic northern ovoid seems to be held in tension. The top edge appears sprung upward, as though from inner pressure; the lower edge makes a slight upward bulge that seems to be caused by the taut downward and inward pull of the two lower corners. There is a feeling that if the ovoid "let go," it would spring back into a rectangle or an oval. In West Coast art, the

19

ovoid is not as frequently used as it is in the north or by the Kwagiutl, nor does it have the look of being in tension, the ends being more softly rounded.

The ovoid may be solid, but more frequently it is an open shape made by a line requiring specific proportions. The upper part of the line is thicker than the lower, the sides bringing about this transition as they curve down into the angular corners, becoming more slender as they do.

To fit a given space, the ovoid can be used in any proportion from elongate and slender to fat and rounded, but the less it is stretched or compressed the more aesthetically pleasing it looks.

In two-dimensional design, large ovoids may be used to delineate the head of a creature or human; they can represent eye sockets or major joints, or help form the shape of a wing, tail, fluke or fin. Small ovoids may contain faces or indicate joints, eyes, ears, noses or the blow hole of a whale. Like other elements they may also serve to fill empty spaces and corners.

The Haida word for "ovoid" is the same word for the large dark spot on each side of a young skate.

Inner Ovoid

The open, linear ovoid frequently contains an *inner ovoid*. This ovoid may be a small and solid, or nearly solid, element representing an eyeball. It may be a *double eye* motif, or a specialized, complex motif termed a *salmon-trout head*. The latter two are northern elements, and generally carry a fine black line around them.

U Form

U forms are another very characteristic feature of Northwest Coast art, and these too can vary tremendously in proportion while maintaining their essential U shape. Large U forms often help to contour the body of a bird or animal, and can be seen as part of the form line in ears, in the tail, forming flukes, and so on. Smaller U forms serve to fill in open spaces and, in Kwagiutl art, often represent the small feathers on a bird's body.

Split U Form

A secondary element often seen in ears, feathers, tails and many other open spaces is the *split U form*, which is frequently used in conjunction with the U form. If the latter is quite

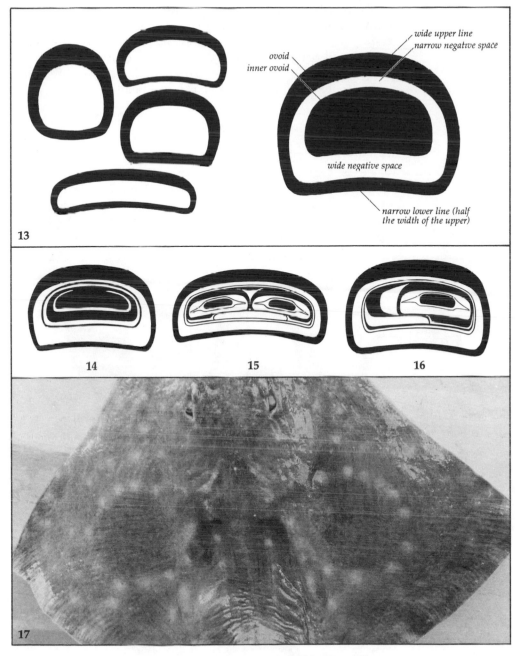

13 Ovoids vary in shape, from elongated to compressed, depending on the design and space in which they are used. At right, the specific proportions required of a classical northern ovoid.

Three types of inner ovoid: **14** the solid (and nearly solid); **15** the double-eye motif; **16** the salmon-trout head motif.

17 A skate, showing the ovoid-like spots on its sides.

broad, a pair of split U's may fill the space. These also have many variations in proportion. The Haida word for the split U shape means "flicker feather," and the reason is clear when a flicker's tail feather is placed inside a U form. The attractive orange and red feathers from red-shafted flickers were often set vertically around the edge of a chief's headdress.

S Form

Another small element used for filling a space is the *S form*, which is derived from two halves of a U form joined in opposite directions. These have many uses in a design: as a connecting element, as part of a leg or arm, or to create an outline. A series of S forms within the body cavity of a creature represents the rib cage.

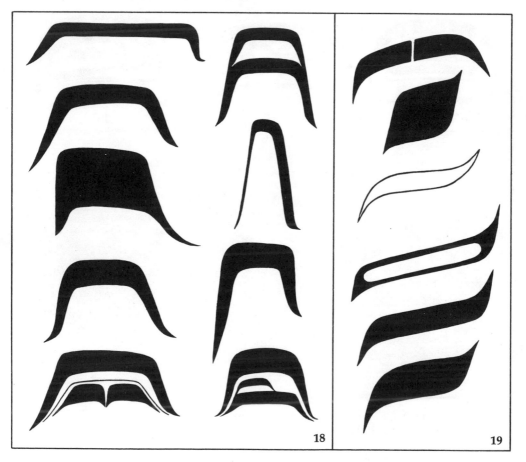

18 Like ovoids, U forms can vary greatly in shape.
19 S forms.

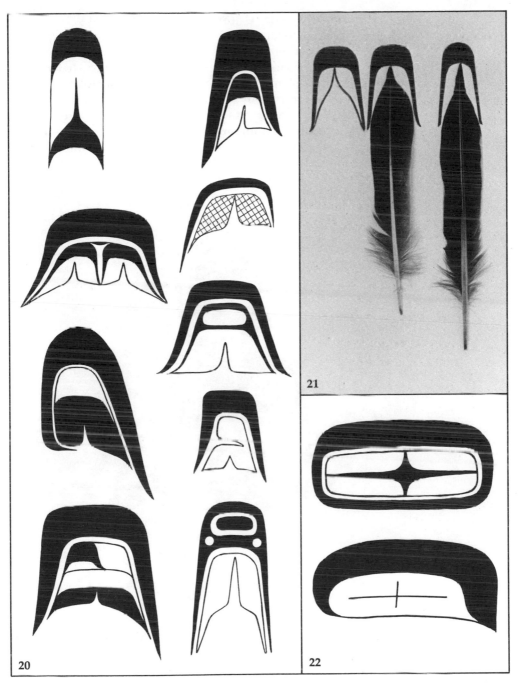

20 Some examples of the many different forms the split U can take.

21 Placed inside a U form, the tail feather of a red-shafted flicker forms a perfect split U.

22 Four-way split U forms.

Form lines, ovoids, U forms, S forms, and the variations of these components are the shapes in which the artist expresses his design concept. When they are assembled in close proximity, the spaces between them create other shapes, and these negative shapes become an essential part of the overall design. The precision of two-dimensional art can be appreciated by realizing that to alter or incorrectly render the line of a positive component is to impair the shape of the negative. A good artist pays attention to such refinements of linear composition.

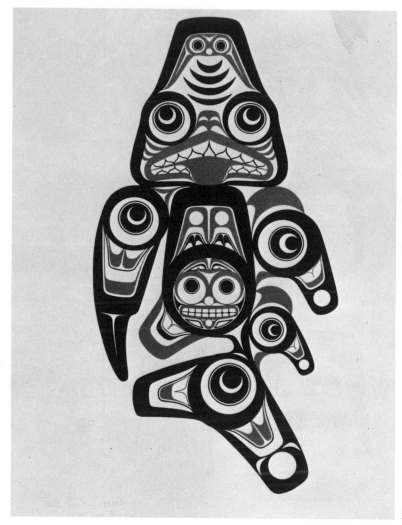

23

23 *Haida Dogfish* by Bill Reid shows a strong form line, U forms, split U forms and a variety of negative relief shapes. The ovoids have been compressed into circles.

3 / Anatomical Features

Body

In selecting the features that will portray his subject, the artist may not always include the body: head, wing, tail and foot will convey a raven or eagle in profile, for instance. Usually, though, the body is quite evident; it may be an elaborate structure, or a simple U form or other shape.

Eyes

The eye comprises the eyeball, generally a circular or ovoid shape, and the eyelid, represented by a fine line around the eyeball tapering to a point at each side. An exception is the West Coast eye, which may have a tapered shape rather than a line. Both eyeball and eyelid are usually placed within an ovoid representing the socket.

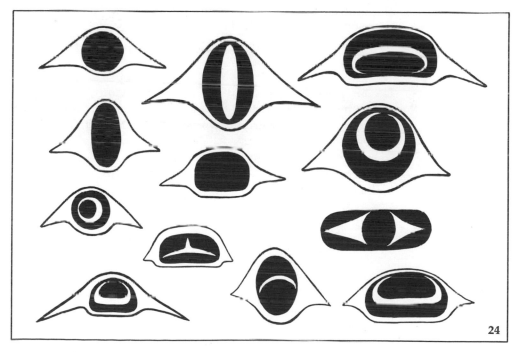

24 A sampling of eyes with eyelids, taken from artists' prints, shows how diverse these features can be.

25

Nose

Not difficult to recognize because of its obvious placement, the nose of an animal can take a variety of forms: large and flaring, small and curled, or very broad. When a figure is seen in profile, only one nostril is shown, and this may often be a small ovoid.

Ears

Since a bear in an upright position can resemble a human, the presence of ears helps clarify it as an animal, for humans are generally not portrayed with ears. Ears are usually a U form on either side of the top of an animal's head, but occasionally they appear as small ovoids with faces inside. A shape referred to as an ear often surmounts the head of the major birds.

Eyebrows

Animals as well as humans may be depicted having eyebrows. There are generally three different but fairly realistic styles— rounded, angular and humped—the latter being characteristic of northern art. Animals carved on northern poles are often depicted with thick, arched eyebrows.

Tongue

The tongue may be protruding and quite obvious, or it may be an abstracted shape within the mouth or beak. The tongue of a bear, often shown protruding, is very evident, but that of a bird can be merely a fine line.

An artist may include a prominent circular disc in the design of a raven's tongue when representing the bird as the bringer of the sun, moon or fire.

25 Nose variations found in animal designs.
26 Examples of animal ears.
27 Rounded, angular and humped eyebrows.
28 Tongues in profile.
29 Tongues facing front are usually protruding.

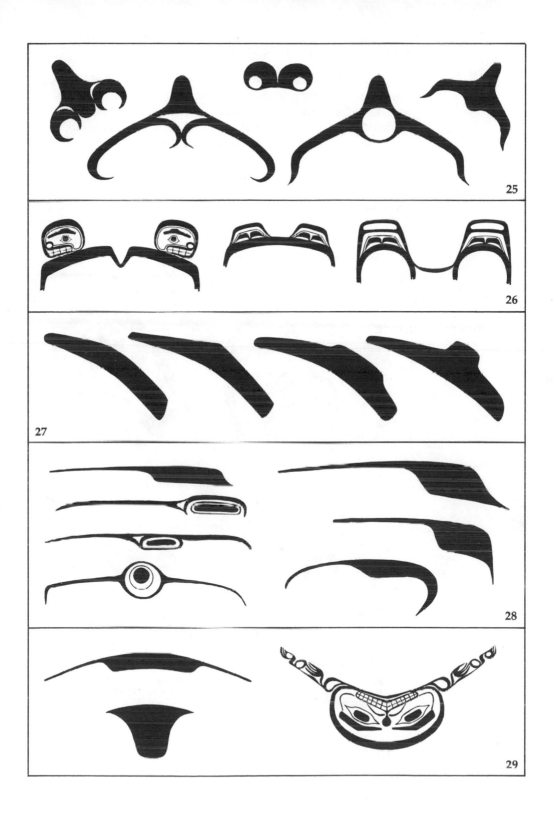

Arms, Legs, Hands, Feet, Claws

Whereas hands, flippers and clawed or toed feet can be a substantial part of the creature being portrayed, the arms and legs to which they are attached are sometimes minimal and difficult to locate. Frequently red, these join the extremities to the body with a "hinged" type of line that often is bent double, indicating a flexed position.

Human hands, often extremely graceful and elegant, show four vertical fingers and a curved-back thumb stemming from an ovoid. This is the classical hand of northern art, and is used as an insignia by 'Ksan, the replica Gitksan village near Hazelton, British Columbia, to identify original hand-crafted art works made by the artists there.

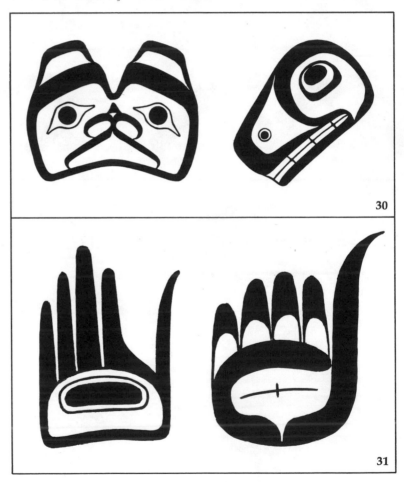

30 Heads: face on and in profile.
31 Human hands are clearly defined by a thumb and four fingers.

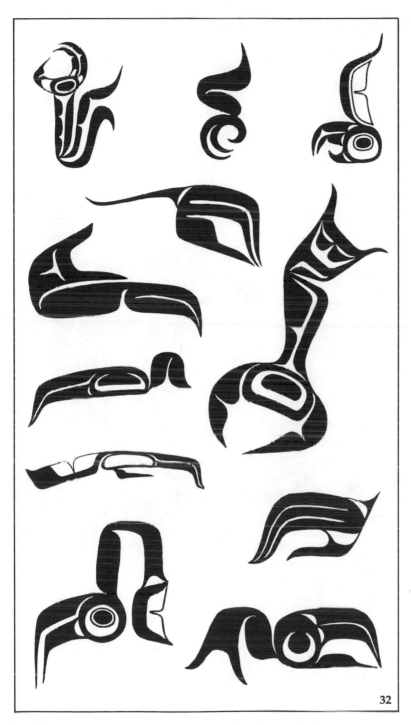

32 Great variation exists in the portrayal of feet and claws, and of the legs to which they are attached.

Bird Feathers, Tails and Wings

Large feathers are generally elongated U forms, usually with split U forms inside; sometimes a pointed tip is added. For breast feathers, a series of small U forms is used.

Most wing designs have a large ovoid joint with a U form attached and often with large feathers added onto the U form. When a bird is shown in profile, a wing may take the place of the body, unless the wings are shown as outstretched.

A bird's tail nearly always has a series of feathers extending from an ovoid, which represents the tail joint and may include a small face.

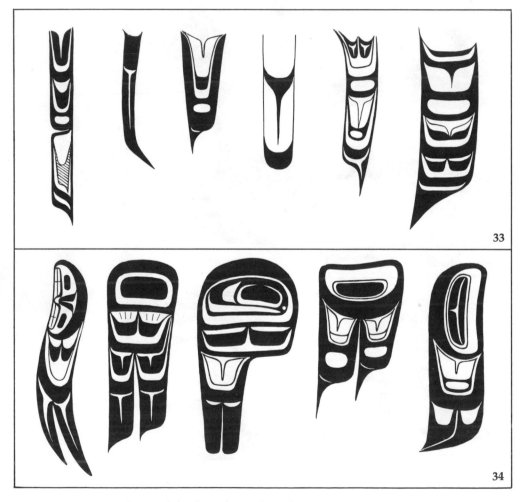

33

34

33 Bird feathers from the different art styles show a broad range of diversity.
34 Bird wings often include an ovoid.

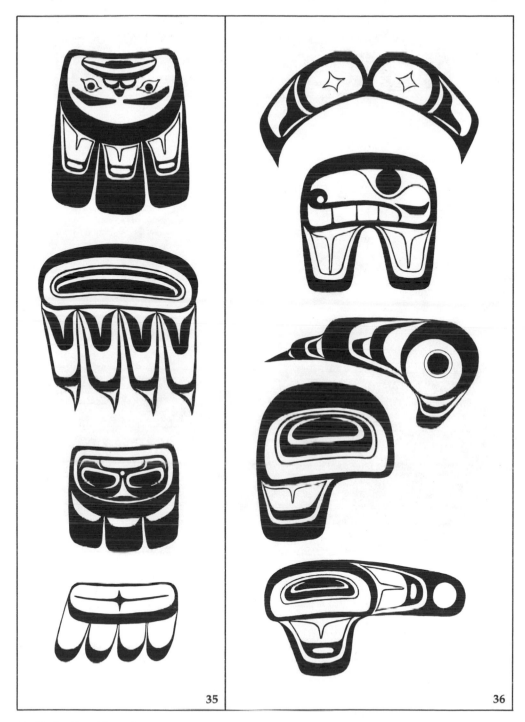

35 Bird tails with stylistic variations.
36 Symmetrical and asymmetrical tail flukes.

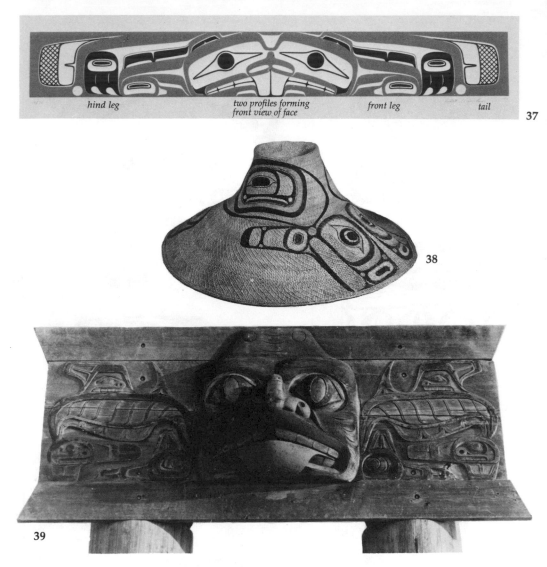

hind leg two profiles forming front leg tail
front view of face

37

37 Split *Beaver* by Robert Davidson is typical of the style of design found on silver bracelets. Beaver's head in the centre is flanked by the front leg, hind leg and crosshatched tail. Also, each side constitutes a beaver in profile, and together the two profile heads create a single front-view head. (Haida)

38 A northern spruce root hat painted with a split whale design. The head and pectoral fin is at the right, the body in the centre, the tail flukes to the left. (Tribe of origin not known)

39 Frontal board on a mortuary pole, by Bill Reid, carved to represent a split dogfish. The head is in the centre; the body is split down the middle and laid out on each side. The shape of the frontal board is patterned after the silhouette of a burial box with a heavy base and lid. Museum of Anthropology, University of British Columbia.

32

4 / Structural Variations

In a detailed, straightforward design, a single crest figure presents no problem of identification. But like its complex culture, the art of the Northwest Coast is seldom simple and direct; it can vary in organization as well as content. Recognizing the following variations can be a useful first step.

Split Figures

A somewhat confusing crest depiction is one that appears to have two bodies and is termed a "split figure." The artist seems to have split the creature down the middle and then laid one half out to each side, with the head as the focal point in the centre. When the head, too, is "split," the two halves that face each other in profile also form a complete head facing front. Alternatively, the two halves may be positioned back to back.

A crest is often split when painted onto a woven hat, each side of the figure going around the raised crown in the centre. Silver and gold bracelets are frequently engraved with split figures; the head occupies the centre, flanked by the body, with the tail at both ends.

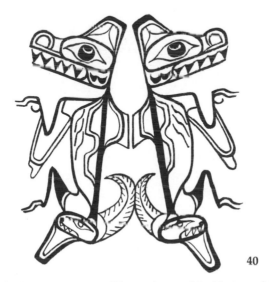

40

40 A tattoo design representing *Wasgo*, the mythical being which is part wolf, part whale. (Haida)

Transformation Figures

In the beginning, according to certain legends, all fauna had the appearance of human beings, until the Transformer came along to designate and transform each into a particular species according to the person's activity, attitude or behaviour at the time of encounter.

Because of the Indians' perception of the oneness of all earth's creatures, human and animal, they held the belief that animals could supernaturally change their appearance at will and take on human form. Similarly, humans could transform into animals, birds, fish and mythical creatures when it was propitious to do so, or as a result of some socially unacceptable behaviour.

This act of transformation was often played out in dances and theatrical presentations, usually with the help of a mask specially designed to create the illusion. In two-dimensional design, transformation is portrayed by showing a creature as part human; just an arm and hand may be sufficient for the purpose. A human head incorporated into a faunal design (other than the ovoid joint) may simply be a reminder that the creature has transformed from human to its present form, or that it is able to do so.

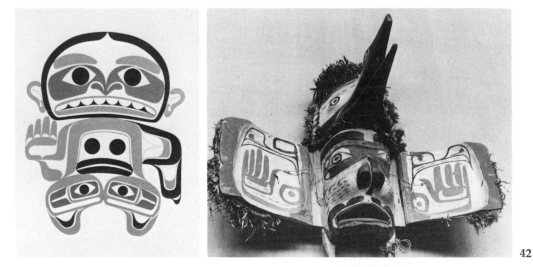

41 The legend of a man transformed into a codfish is recalled in *Hanu-quatchew,* by Joe David, which shows the creature as half man, half fish. (West Coast)

42 Kwagiutl transformation mask. The wings of Raven (upper mask) open to reveal a human head; upraised hands are painted on the inside of the wings. Rasmussen Collection, Portland Art Museum, Portland, Oregon.

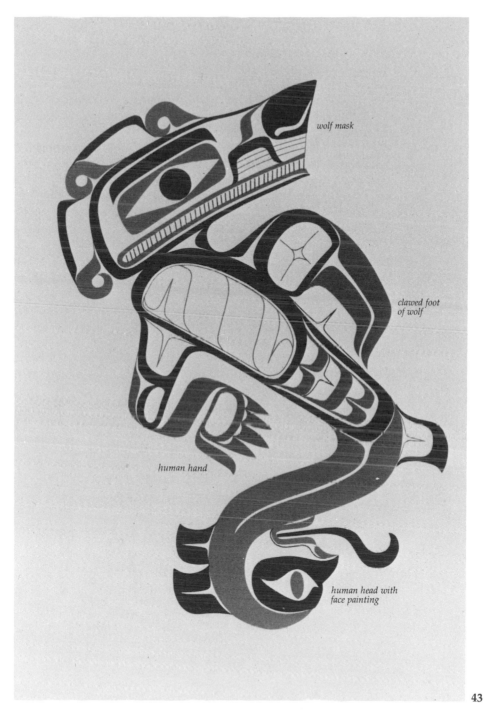

wolf mask

clawed foot
of wolf

human hand

human head with
face painting

43 *Serpent Dancer* by Joe David portrays the transformation of the dancer, in serpent headdress, into the mythical being. The head, arm and hand are still in human form. (West Coast)

A Design Fitted to a Given Shape

When a crest portrayal is applied to an item having a specific shape—a rattle, hat, spoon or drum, for example—the general outline of the crest is usually contained by the shape of that item, the design having been manipulated to fit. This arranging of anatomy to fit a specific shape is necessary in jewellery making, where the artist creates a design to conform to the bracelet, pendant or other piece. The technique has influenced contemporary print makers to design within a particular shape, even though the paper allows a free contour.

In rearranging the anatomy of a crest figure, the artist can also bend, distort or exaggerate—even eliminate—some of the body parts so as to fill the given shape and create a pleasing composition.

All this can make the design more difficult to interpret, but the key symbols will always be included, and by finding them and understanding the arrangement, one can see the subject without too much difficulty. An exception is when the various parts of the crest are totally broken up and distorted, in order to cover every inch of the given shape; then the design becomes a complete abstract. It is usually impossible to recognize the subject of such a design; the Chilkat blanket is an example.

A selection of designs, all representing the whale, show how this sea mammal can be arranged and even abbreviated to fit a particular shape, and yet retain its identity. The diagrams on the following pages will help to clarify the distortions.

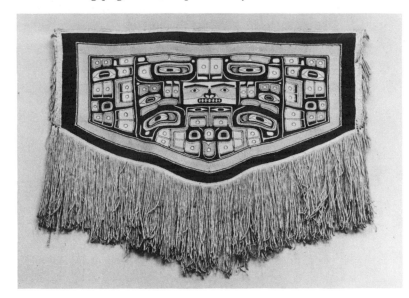

44

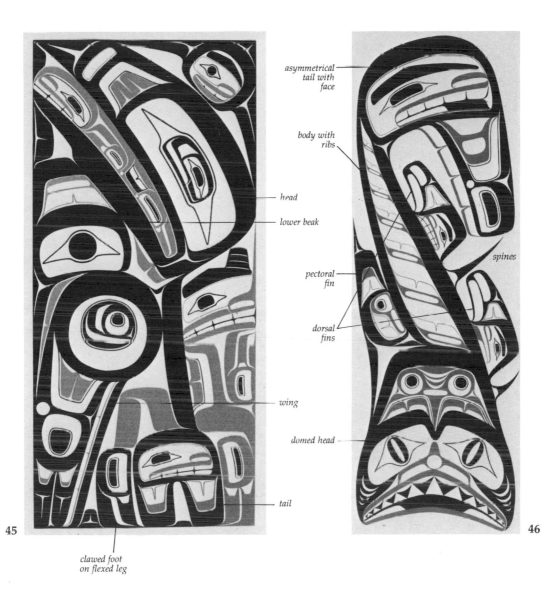

asymmetrical
tail with
face

body with
ribs

head

lower beak

spines

pectoral
fin

dorsal
fins

wing

domed head

tail

45

46

clawed foot
on flexed leg

44 As with almost all Chilkat blankets, the subject has been totally broken up and abstracted, to the point of becoming unrecognizable. Rasmussen Collection, Portland Art Museum, Portland, Oregon. (Tlingit)

45 Filling every part of the rectangle, *Raven Stealing the Moon* by Robert Davidson includes all elements of the legend, fitted into one mosaic-like design. (Haida)

46 Robert Davidson arranged the elements of this *Dogfish* design to fit the slender vertical format. (Haida)

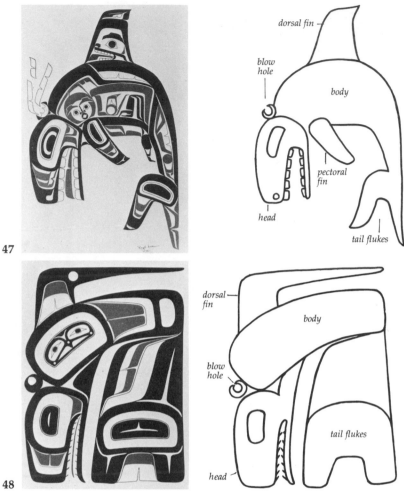

47 *Killer Whale* by Roy Vickers is an easily recognized portrayal of a whale broaching, and carries all the identifying features for this crest. ('Ksan)

48 Freda Diesing's version of *Haida Whale* shows modification to fit a rectangle. The dorsal fin has been sharply bent over and elongated, and the body and tail flukes have been compacted to conform to the vertical and horizontal boundaries. To fill the rest of the space, the tail has been exaggerated.

49 Totally filling a narrow vertical field, Robert Davidson's *Killer Whale* is depicted simply by the head and the blow hole, with the dorsal fin above and the pectoral fin below. Other elements of the design fill out the contour and form the edges of the shape, making a continuous black border. (This print is shown in reverse for easier comparison.) (Haida)

50 In its most minimal statement, the *Killer Whale*, also by Robert Davidson, is now reduced to only the head, blow hole and pectoral fin, with a few design elements added to complete the circular outline. (Haida)

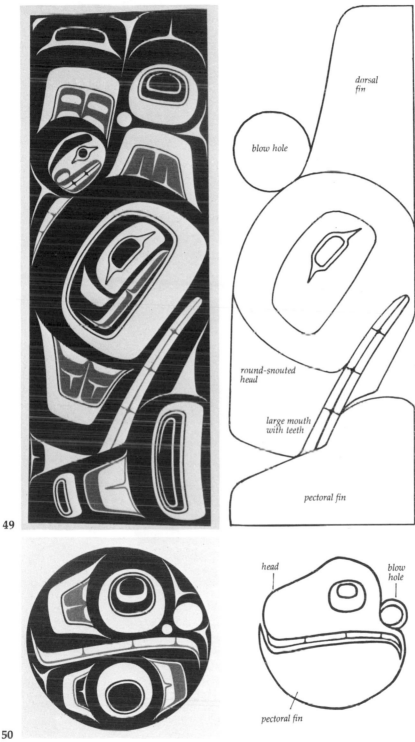

49

50

dorsal
fin

blow hole

round-snouted
head

large mouth
with teeth

pectoral fin

head

blow
hole

pectoral fin

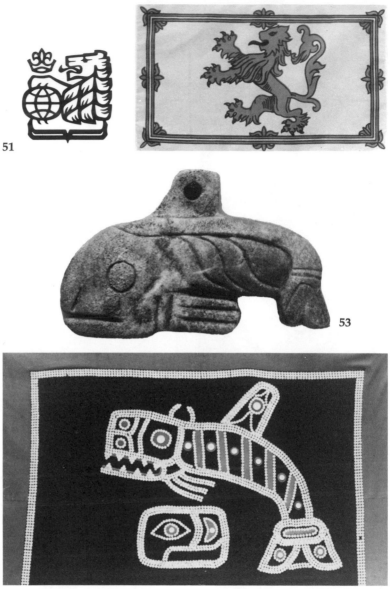

51 The emblem of the Royal Bank of Canada.

52 The lion on the banner of the King of Scots.

53 Shaman's killer whale charm carved from whale bone has a short fin with a hole in the centre, and shows ribs. 12 cm (5¾ inches). Rasmussen Collection, Portland Museum of Art, Portland, Oregon. (Tlingit)

54 A Tlingit button blanket portraying *Killer Whale and the Rock It Was Stranded on While Chasing a Seal*. The whale has the customary large mouth, blow hole, dorsal fin and tail flukes. The rock bears a stylized salmon-trout head design. Rasmussen Collection, Portland Museum of Art, Portland, Oregon.

40

5 / Identification of Design Motifs

The lion depicted on the banner of the King of Scots is very different from the crest of the Royal Bank of Canada, yet each has a large mouth and protruding tongue, a shaggy mane and big paws as identifying symbols. If only the shaggy mane were depicted, the animal could still be recognized as a lion.

Similarly, for each of the mythical and crest figures of the Northwest Coast Indians, certain characteristic features have become the means of identification. A whale leaping may be shown with five or six of its distinguishing characteristics; a minimal version of a whale could have only one or two. But all such symbols are the result of work by generations of artists who have built up the conventions of the art through stylized portrayals.

Contemporary prints often depict several characters and inanimate objects as well, though some of the figures may be elemental. When two or more are combined, the design generally illustrates a legend or a significant activity such as whaling.

The following pages give examples of the most frequent representations of crest and mythical figures in two-dimensional design, with occasional reference to three-dimensional objects bearing the same motifs. Considerable enjoyment and appreciation of the art can be gained through learning to identify such figures by the features, or combinations of features, that are distinctive to each. This step often follows easily when the form lines have been perceived and the structures made by ovoids and U forms have been seen as wings, tails, fins, beaks, and so on. However, it should be remembered that no two artists visualize a figure in the same way, and that the possibilities for variations are tremendous.

Whale, Killer Whale

Since ancient times, seafarers have held in awe those great mammals of the ocean, the whales, and have made them the subject of fantasy and superstition.

The West Coast people, and the Makah living on Cape Alava on the Olympic Peninsula in Washington, actively hunted the grey whale. They were the only people along the entire Northwest Coast to do so, and they sought success in the hunt through months of rigorous ceremonial preparation.

Many legends and beliefs grew up around the great sea mammals. If a whale were injured but not killed in the hunt, it would return at some other time and capsize the whaler's canoe. A widespread belief held that a whale could capture a canoe and drag it and all those aboard down to the underwater Village of the Whales. Once there, the people would be transformed, and themselves become whales. The Haida believed that whales appearing in front of a village were drowned persons returning to communicate with the people.

The Tsimshian saw whales as being members of four clans, and represented them differently in design. This concept may have originated with the recognition of various whale species. The Eagle clan of the whales had a white stripe across the middle of the dorsal fin, the Wolf clan carried a long dorsal fin like a wolf's tail, the Raven clan's fin resembled a raven's beak, and the Gispawadwe'da (no translation) had a short fin with a hole in the centre.

The Haida have a legend of Raven-finned Killer Whale, a whale chief who carries a raven perched on top of his tall dorsal fin, and there are legends of two-, three- and even five-finned killer whales. These legends could have originated from the sight of a cluster of dorsal fins where whales surfaced together, as often happens.

Whales are prolific in the art of the Northwest Coast peoples and are a frequent motif with print makers. The distinguishing features are clearly defined, and two or more are always present no matter how minimal the portrayal. They are: a round snouted head with large mouth and many teeth, a blow hole, a dorsal fin, a pectoral fin, and a tail with symmetrical flukes—although in profile the latter can appear asymmetrical.

Bear, Grizzly Bear, Sea Bear

The bear is the subject of many legends and superstitions and is often featured in art works, particularly totem poles and button blankets, as it is an important family crest.

A well known Haida legend (shared also by other cultures) is that of a woman who was abducted by a bear while berry picking. She married the bear and subsequently gave birth to twin cubs.

Because of its power and human-like qualities, the bear was referred to by West Coast people as "Elder Kinsman." When killed, it was taken to the chief's house, sprinkled with eagle down (a symbol of welcome and friendship) and generally treated as a high ranking guest.

The bear is defined by having ears, large flaring nostrils, a wide mouth with conspicuous teeth (which may include canines) and often a protruding tongue. Claw-like hands and feet are characteristic, unless the animal is the legendary Sea Bear, in which case, because it is part whale, it has fins. The minimal tail of the bear is generally ignored.

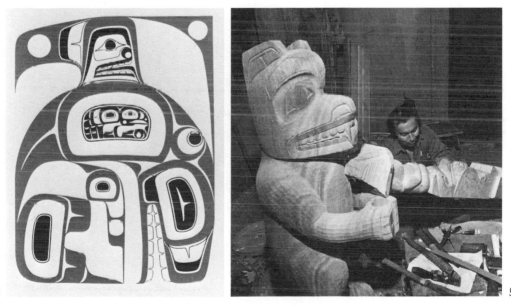

55 56

55 *Raven inside of a Whale* by Freda Diesing. The broaching whale faces right with its head down. The inner ovoid of the body contains a raven design; the head and beak are in the upper right section, the upper left has a wing with three tail feathers below, and the clawed foot is at the lower right (Haida)

56 Walter Harris working on a talking stick which will fit into the hands of the bear he has carved. ('Ksan)

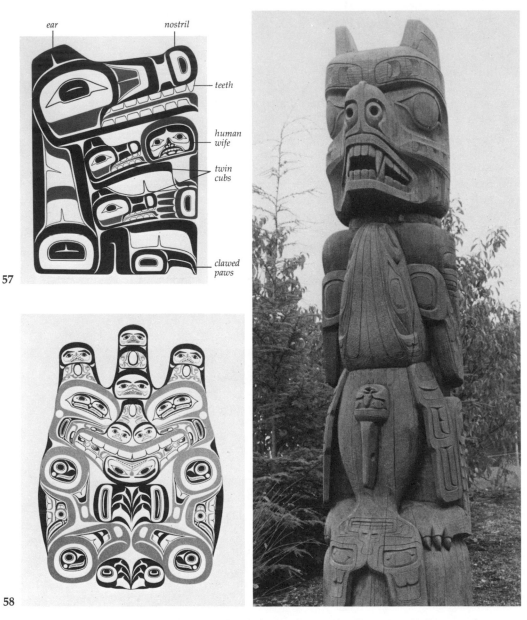

57 *Haida Bear and Cubs* by Freda Diesing illustrates the bear mother story with small twin bear heads in the centre and the human mother to the right, portrayed by her hand and head. Note the labret in the lower lip.

58 Bill Reid uses many small figures in a decorative way for his *Haida Grizzly*. They form the protruding tongue and the nostrils, create ears, and fill the rank rings rising between the ears. Shoulder and hip joints are prominently featured in this work.

59 *Bear with Whale*, carved by Henry Hunt, stands near the Swartz Bay ferry terminal on Vancouver Island. (Kwagiutl)

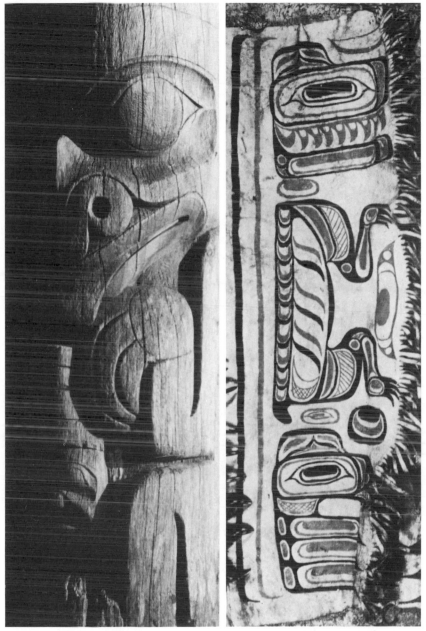

60 **61**

60 Part of an old pole from the abandoned village of Tanoo, Queen Charlotte Islands, showing a bear with a high-ranking person between the paws. Museum of Anthropology, University of British Columbia. (Haida)

61 The border design, painted on both sides of a chief's ceremonial robe of hide, represents a bear, with an eagle beneath. Thomas Burke Memorial Washington State Museum. (Tlingit)

Wolf

Revered because it was a good hunter, the wolf was often associated with the special spirit power a man had to acquire to become a successful hunter. The wolf was the land manifestation of the killer whale. According to West Coast legend, a supernatural white wolf transformed itself into a killer whale; hence these sea mammals' white markings and their habit of travelling in groups, as wolves do.

The wolf is still an important family crest and is often represented on the personal possessions of those with the right to use it.

Generally seen in profile, Wolf may be depicted crouched on all fours, or sitting with front paws raised. The four main features of identification are: elongated snout with flared nostrils, large and many teeth (which may include canines), prominent ears, and a curled-over tail. The latter may have a series of diagonal curved lines representing its bushiness.

The addition of fins or flippers indicates that the animal is the mythical Sea Wolf known to many tribes and called Wasgo in Haida legend.

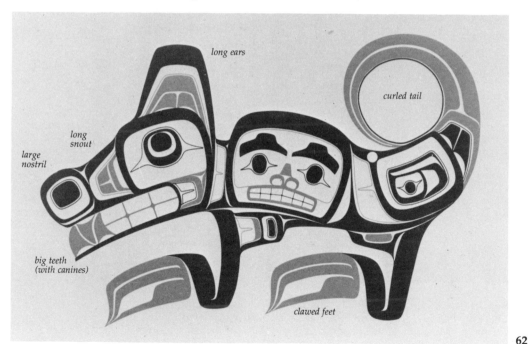

long ears

curled tail

long snout

large nostril

big teeth (with canines)

clawed feet

62 *Wolf* by Gerry Marks has all the identifying features of this animal, including canine teeth. The design is well conceived to fit the rectangular shape. (Haida)

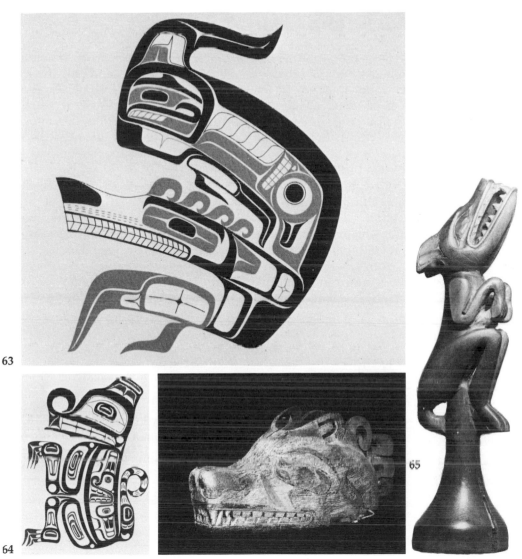

63 *Crawling Wolf Dancer* by Joe David captures the full sweeping turn made during this fast-moving dance. The dancer wears a typical West Coast wolf mask with curled elements across the top.

64 In characteristic Kwagiutl style, *Wolf* by Tony Hunt is filled with decorative elements and has a curled tail with diagonal stripes for bushiness, plus dash lines.

65 One of four wolf masks originally placed on the four corner posts of a grave at Ahousat, off the west coast of Vancouver Island. Museum of Anthropology, University of British Columbia. (West Coast)

66 A wooden pestle for mashing fish eggs, carved in the form of an upright wolf. The tail in this case is turned down, rather than up, to give balance and strength to the shaft. Rasmussen Collection, Portland Art Museum, Portland, Oregon. (Tlingit)

47

Mountain Goat

When snow conditions in the rugged coast mountains become too severe for mountain goats, they descend to lower elevations. A famous legend of the Tsimshian relates how the village of Temlaham in the Skeena valley was destroyed when mountain goats caused a landslide that killed all but one man. The destruction was punishment for the maltreatment of a baby goat by children. The lone survivor was the one who had rescued the goat from its tormentors.

Mountain goat wool was the basic material from which magnificent blankets were woven by the Chilkat women of the Tlingit people; Chilkat blankets were later made by the Tsimshian as well. The animals' curved black horns were molded into delicate spoons with exquisitely carved handles.

A mountain goat may occasionally be seen carved on a totem pole, and can readily be identified by the two slender horns standing out in relief. Small hoofed feet confirm its identity.

Otter

As the legendary Transformer journeyed about, transforming people into creatures of the animal world (see p. 34), word of his coming preceded him. When he came upon a man sharpening a spear for the purpose of killing him, the Transformer took the spear, attached it to the man's rear like a long pointed tail, and turned him into an otter.

In a simplified version of the otter, this design originated as a banner for summer street decoration. The rounded head, long pointed tail and four clawed feet typify the otter in this realistic rendering.

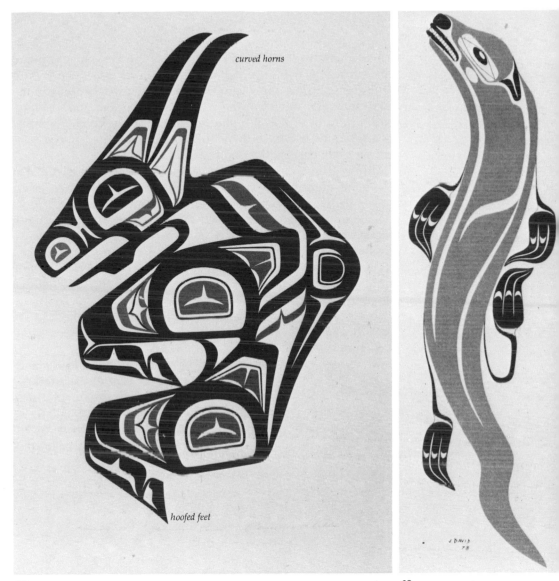

curved horns

hoofed feet

67

68

67 Occasionally seen on totem poles, the *Mountain Goat,* here by Coast Tsimshian artist Clarence Wells, is identified by its two curved horns and hoofed feet.

68 Joe David portrays the lithe body of the *Otter* with semi-realism, emphasizing the long pointed tail. Note the split U forming the animal's small ear. (West Coast)

Beaver

A Tsimshian legend tells of the origin of the beaver. A woman with brown hair dammed a small stream to make a pool for swimming, and as she swam, her leather apron kept slapping the water. The pool became a lake and, because of scolding words from her husband, she refused to leave it. She became covered all over with brown fur, her apron turned into a tail, and thus she became the first beaver.

Although Beaver always has ears and rounded nostrils, the two most identifying symbols are the tail and the two large incisor teeth. A design depicting this animal, no matter how stylized or distorted to fit a given shape, will always carry these telltale symbols. Quite often a U form, the tail is always crosshatched to resemble the patterning of the scaly surface, but it may also carry a human face which represents the tail joint. When the beaver is shown facing front, the tail is generally drawn up against the stomach. The incisor teeth are close together and not pointed as are the canines of the bear or wolf. Beaver will often be carrying a chewing stick in front paws that have fingers.

Beaver, an important crest of the Haida and the subject of many legends, figured on many items of functional, ornamental and ceremonial property, and is still a much used crest on silver and gold jewellery and button blankets as well as silkscreen prints.

69

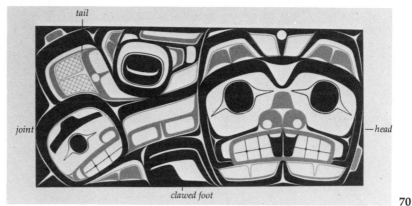

69 A Haida halibut hook in the Rasmussen Collection, Portland Museum of Art (Portland, Oregon) depicts a beaver by showing only its head and crosshatched tail.

70 Gerry Marks's *Beaver* has been designed to fill the rectangular shape. The head is facing front, but the body is in profile. (Haida)

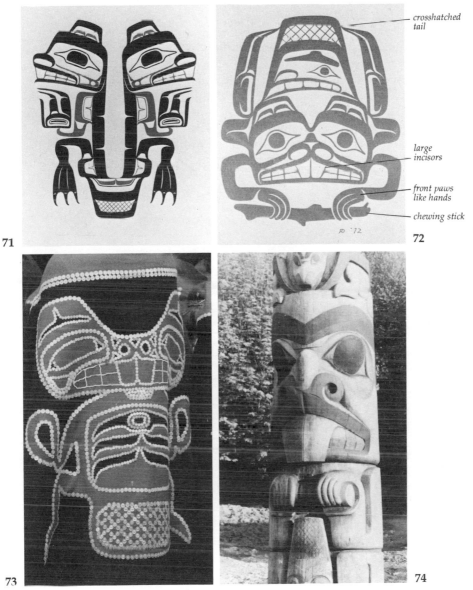

crosshatched tail

large incisors

front paws like hands

chewing stick

71

72

73

74

71 *Beaver* is depicted as a vertical split figure by Robert Davidson. (Haida)

72 Clutching its chewing stick, *Beaver* by Robert Davidson has all the attributes of this animal. (Haida)

73 A button blanket worn during the 1978 pole-raising ceremonies at Skidegate, Queen Charlotte Islands, shows that the owner is under the Beaver crest. (Haida)

74 A classic Haida beaver clutching its chewing stick is at the base of a pole carved by Bill Reid. Museum of Anthropology, University of British Columbia.

Sea Lion

Sea lions were hunted most often in the northern waters where they breed, and their long, thick whiskers were used in a crown-like effect around the top of a chief's headdress.

Larger and more slender than the seal, the sea lion has external ears and longer tail flippers, and it uses its fore flippers for swimming. This portrayal catches the graceful character of the sea mammal, shows the small ears behind the eye, and emphasizes its prominent fore flippers.

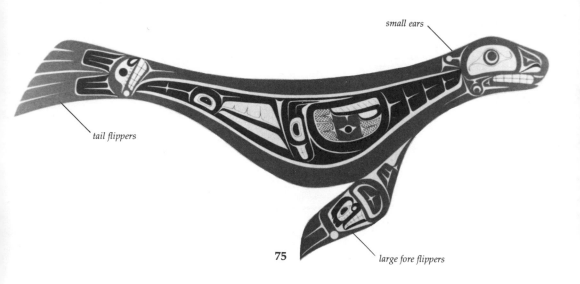

small ears

tail flippers

75

large fore flippers

75 *Sea Lion,* by Hupquatchew of the Opetchesaht tribe, portrays the sea mammal once hunted by his people on the west coast of Vancouver Island. (West Coast)

Seal

The seal is stubbier than the sea lion and has a more rounded snout and shorter flippers. Because the flippers are not used in swimming, they are only minimally defined in design.

Seal hunting was of great importance to the people of the West Coast, who preserved the meat for winter, rendered the oil, and used the inflated skins as floats in whaling.

A Tsimshian legend tells of a two-headed self-propelled canoe that creaks when it is hungry. Like the canoe form of Sisiutl, it must be fed seals.

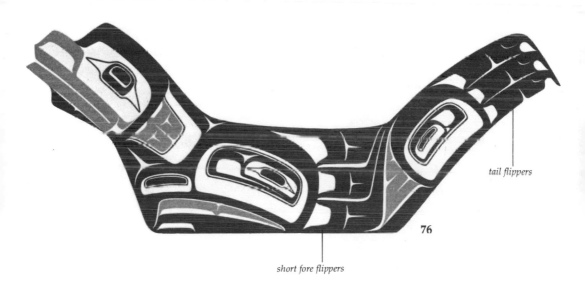

tail flippers

76

short fore flippers

76 *Seal Bowl.* Robert Davidson's design puts the idea of a carved bowl into a two-dimensional image. (Haida)

Eagle

A symbol of power and prestige among many nations of the world, the eagle is also important to the Indians of the Northwest Coast, who share their environment with this majestic bird.

Many myths and legends surround Eagle; eagle down, a symbol of peace and friendship, was, and still is, sprinkled before guests in welcome dances and on other ceremonial occasions; eagle feathers were used in rituals and worn on masks and headdresses. Eagle is one of the two main Haida crests, and many families of the coast still own or inherit the right to use it. As a result, portrayals of this powerful bird are to be found painted and carved on many museum items, and it has been a source of inspiration to many of today's native print makers and designers.

Eagle's beak is considerably shorter than that of Raven, and terminates in a strong downward curve; the tongue is generally evident also, as are the U-form "ears" which convey the crestlike look of the bird's head. It would be easy to confuse the Eagle with Thunderbird, except that Eagle never has curled appendages extending from the top of its head, and its beak is not strongly recurved like Thunderbird's.

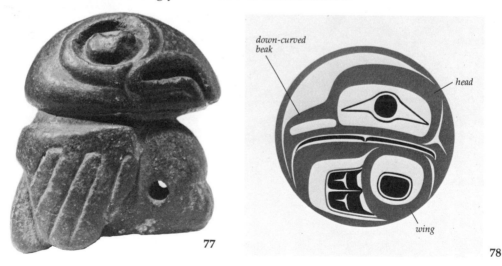

77

78

77 A small eagle carved in stone, 5.6 cm (2¼ inches) in height, from Greenville, Nass River. British Columbia Provincial Museum, Victoria, B.C.

78 The down-curved beak is the single identifying symbol for *Eagle* by Robert Davidson. The head occupies the upper half of the circle, and the wing fills in the lower section of this very contracted version of the Haida crest.

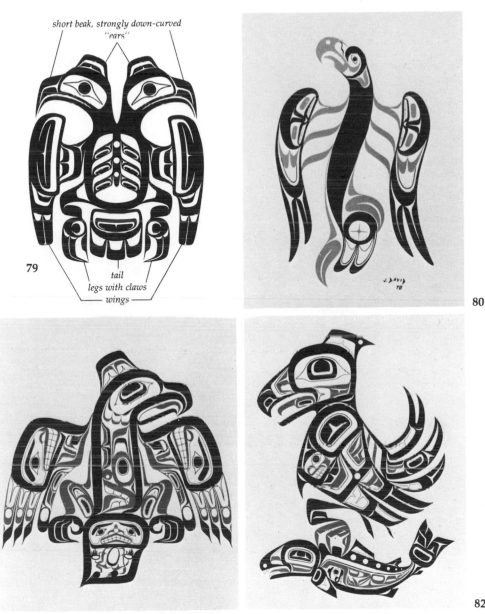

79 In Robert Davidson's design of *Two Headed Eagle*, S forms indicate the rib cage. (Haida)

80 *Eagle* by Joe David, an asymmetric design with a four-way split in the circle at the tail joint. (West Coast)

81 Bill Reid boldly incorporates faces into the wing and tail joints of *Haida Eagle*.

82 *Eagle with Salmon*. Earl Muldoe's rendering illustrates a familiar scene at spawning time. Inside the body of the fish is a human portrayal, a reminder that salmon are people in fish form. ('Ksan)

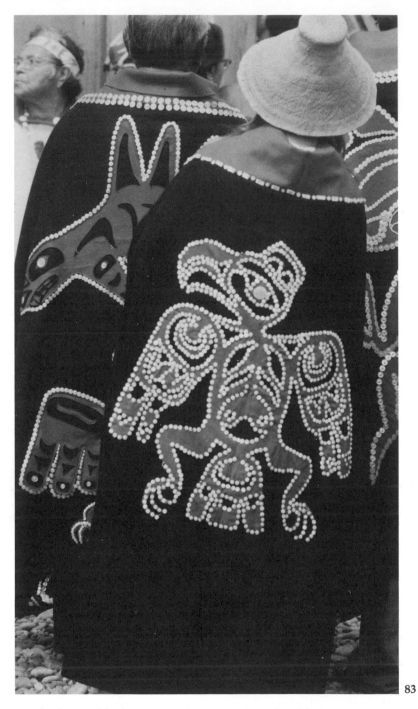

83

83 This button blanket has a red eagle appliquéd on black and outlined with hundreds of buttons. The wearer, from Old Masset, belongs to the Eagle clan. (Haida)

Raven

Most important of all creatures to the coast Indian peoples was Raven. It was Raven—the Transformer, the cultural hero, the trickster, the Big Man (he took many forms to many peoples)—who created the world. He put the sun, moon and stars into the sky, fish into the sea, salmon into the rivers, and food onto the land; he manoeuvred the tides to assure daily access to beach resources. Raven gave the people fire and water, placed the rivers, lakes and cedar trees over the land, and peopled the earth.

Full of magical, supernatural power, Raven could turn himself into anything at any time. He could dive beneath the sea, ascend into the sky, or make anything happen by willing it. His legendary antics were often motivated by insatiable greed, and he loved to tease, to cheat, to woo, and to trick. But all too often the tables were turned on the hapless Raven.

As well as being deeply embodied in the mythology of the entire Northwest Coast, Raven is also an important totem figure of prestige, and is one of the two main crests of the Haida on the Queen Charlotte Islands.

In the past, Raven was probably portrayed more often, and in more ways, than any other creature of legend. Today, Indian carvers, jewellers and print makers still hold a fondness for the wily Raven, and feature him often in their works of art.

Raven is distinguished by a fairly long, straight beak having a blunt or short turned-down tip, and usually a tongue. A sun

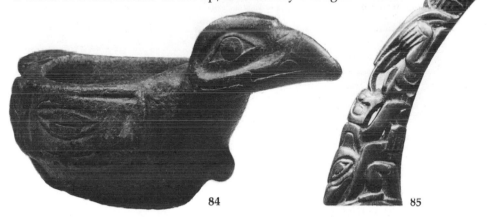

84

85

84 A stone tobacco mortar in the form of a raven. British Columbia Provincial Museum, Victoria, B.C. (Haida)

85 The tip of a spoon handle that has been carved from mountain goat horn to represent a raven. Arms in addition to wings signify Raven's ability to transform into a human. Collection of Mrs. W. H. Cross, Sidney, B.C. (Haida)

disc in the partially open beak is a reminder that Raven flew with it in his beak and tossed it into the sky to bring light to the world. The moon or fire also can be represented by a circle in Raven's beak.

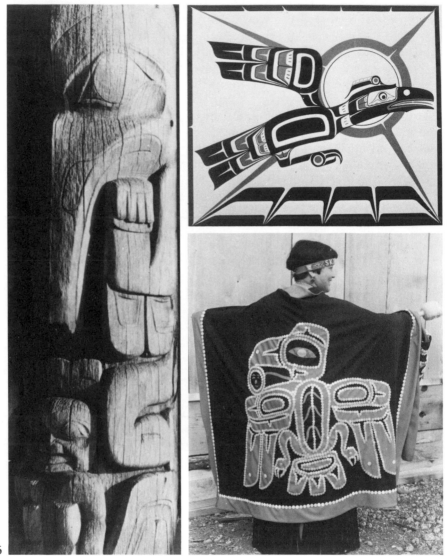

86

87

88

86 Part of a pole from Tanoo, on the Queen Charlotte Islands, shows Raven with wing feathers on his human arms with hands. Museum of Anthropology, University of British Columbia. (Haida)

87 *Raven* by Jerry Smith shows the bird in association with the sun. (Kwagiutl)

88 Laura McIntyre, formerly of Skidegate, Queen Charlotte Islands, wears a button blanket displaying Raven, her clan crest. (Haida)

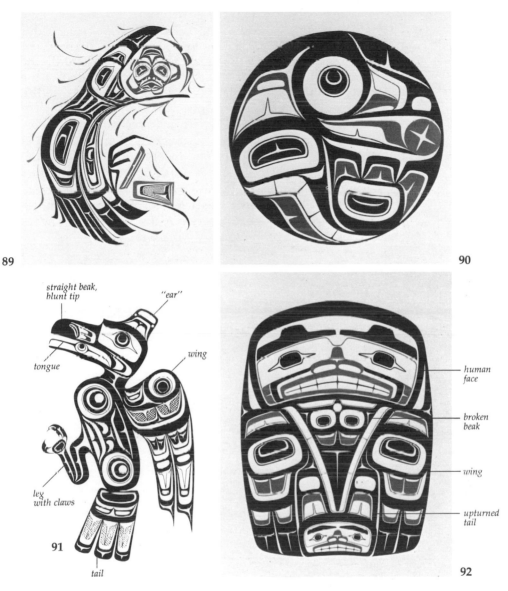

89 An energetic design of *Raven Stealing the Sun*, by Ken Mowatt, includes the box in which the sun was kept before Raven took it in his beak to the sky. ('Ksan)

90 Don Yeomans's version of *Raven* inside a circle creates a near-abstract design. (Haida)

91 Profile design of *Raven*, by Kwagiutl artist Tony Hunt, is the emblem for his Indian arts store in Victoria, B.C.

92 *Raven with Broken Beak* by Gerry Marks recalls the tricky bird's attempt to steal bait from a blind fisherman's halibut hook; the unusual depiction of the beak—vertical beneath the chin—signifies that it is broken. (Haida)

59

Hawk

Less often depicted than Raven, Eagle or Thunderbird, the hawk nevertheless takes its place in the spiritual world of the supernatural and inspires interesting designs for masks, rattles and silver jewellery as well as prints.

Hawk, with its recurved beak, strongly resembles Thunderbird. However, the hawk's beak is generally shorter, and often the recurved tip of the upper jaw meets with the tip of the lower jaw, or continues beneath it. In addition, the hawk does not have curled horn-like symbols emanating from its head.

Among the Haida, Hawk was used to represent Thunderbird, so making a distinction between the two is not always possible, except in a contemporary work with a title.

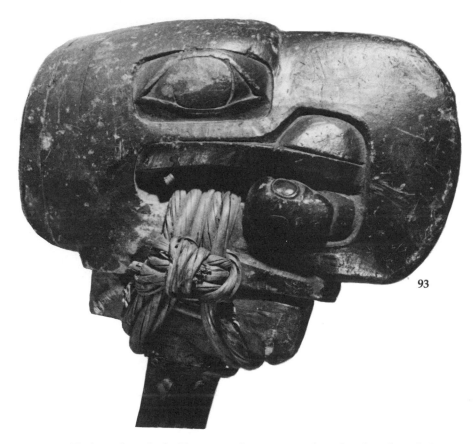

93

93 A northern hafted hammer of stone, carved as a hawk with a whale in its mouth. National Museum of Man, Ottawa. (Haida)

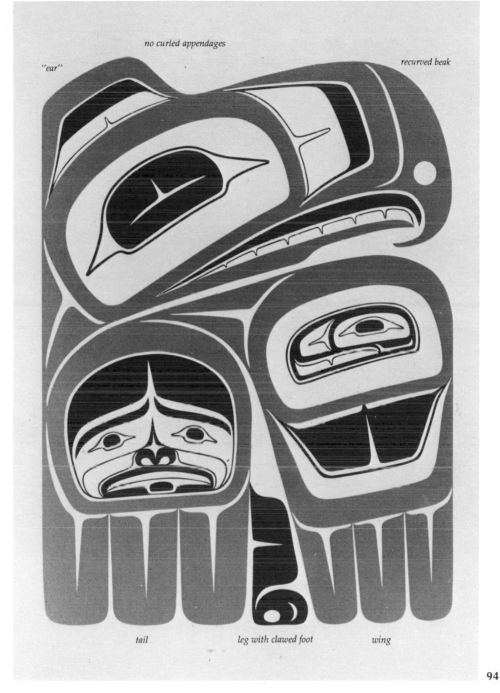

no curled appendages

"ear"

recurved beak

tail leg with clawed foot wing

94 *Haida Hawk* by Freda Diesing has a recurved beak to distinguish this bird from the eagle. The human face in the wing joint is female—perhaps because the artist is.

Hummingbird

The hummingbird is a motif seldom seen in Northwest Coast art. In his design, Art Thompson portrays the characteristics of this small bird called *Sah Sin* by his people.

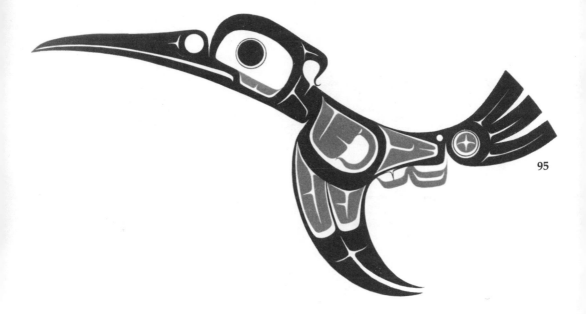

95

95 *Sah Sin* by Art Thompson. (West Coast)

Loon

To us, the loon's call through the early morning mist of a lake, or out on the sea, is a melancholy sound. To the people inhabiting the west coast of Vancouver Island long ago, the deep voice of the red-throated loon was frighteningly eerie. This bird is said to have delighted in scaring those on shore or in canoes, especially in the fog that so often rolled in to shore in summer. The Indians gave the bird's summer plumage an apt but unflattering name meaning "maggots on the back."

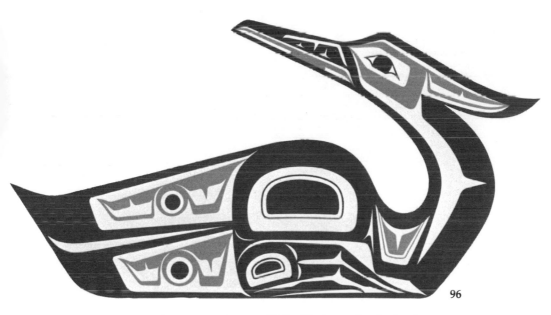

96 *Loon* by Coast Tsimshian artist Clarence Wells. The long, slender beak and tufted head give this bird its distinctive look.

Owl

Perhaps because of its silent flight, eerie call and nocturnal habits, the owl was often associated with death. Among the Kwagiutl, a person who was soon to die heard the owl call his or her name, and the Tsimshian believed that this bird, which was commonly a shaman's helper, could cause death to the person whose head it flew over.

In Tlingit myth, a selfish woman refused to share her catch of herring with her husband's mother. When the old woman tried to take some of the fish from the cooking box, the selfish wife dropped a hot rock on her hand as she was reaching in. As punishment, the wife was transformed into a screech owl.

In design the owl has large, round eye sockets and a short, sharp beak.

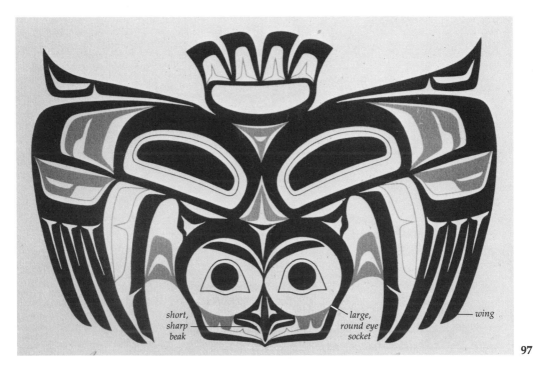

97

97 The subject of *Owl* by Roy Vickers is recognized by its large eye sockets and short beak. ('Ksan)

Thunderbird

Thunderbird! The very name of this marvellous creature of myth stirs the imagination. To many North Americans, the name Thunderbird is synonymous with an automobile, but to the West Coast people this great bird, living high in the mountains, was the most powerful of all the spirits—the personification of "chief." Only the most powerful and prestigious of chiefs has Thunderbird as a crest.

When Thunderbird was hungry he ate whales. On the West Coast, he grasped the two Lightning Snakes which lived under his wings and threw them down onto a surfacing whale. The snakes, striking with their lightning tongues, killed the sea mammal; then Thunderbird swooped down, picked it up in his strong talons and flew with it to the mountains, there to devour it.

Knowing of its skill in striking whales, a whale hunter would paint a Lightning Snake on his canoe, and then paint over the image. Although it was unseen by the whale, the power of its presence on the canoe would aid the hunter to make a strike. The Lightning Snake has the head of a wolf, an animal also revered for its hunting prowess.

To the Kwagiutl people there were several Thunderbirds having different names, and they too were associated with whales. When the chief of a Thunderbird clan died, thunder rolled; when the great bird blinked its eyes, lightning flashed. Even the Haida and the Tlingit in the north have legends of this supernatural whale-eating bird.

On totem poles, as in prints, Thunderbird is always shown with great outstretched wings. Its distinguishing features are the curled appendages on the top of the head (said by some to be power symbols) and the sharply recurved upper beak which is similar to Hawk's beak.

98

98 *Haida Thunderbird* by Sharon Hitchcock is based on the hawk, and has no curled appendages on its head.

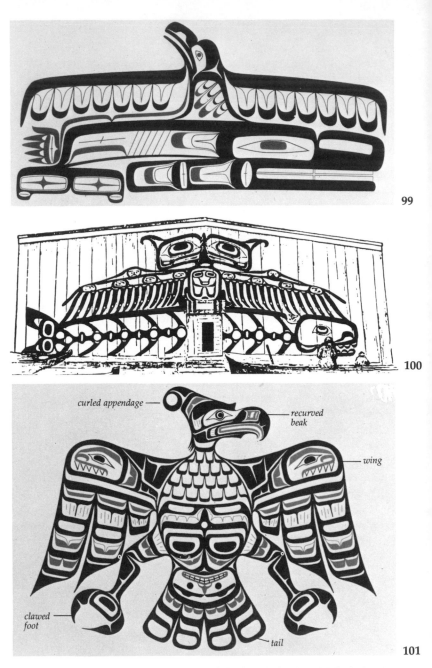

99 A West Coast image: the powerful *Thunderbird and Whale* by Joe David.

100 A nineteenth-century house front painting of Thunderbird carrying off a whale. Alert Bay. (Kwagiutl)

101 *Kwagiutl Thunderbird* by Richard Hunt shows breast feathers, and includes faces in the wing and tail joints.

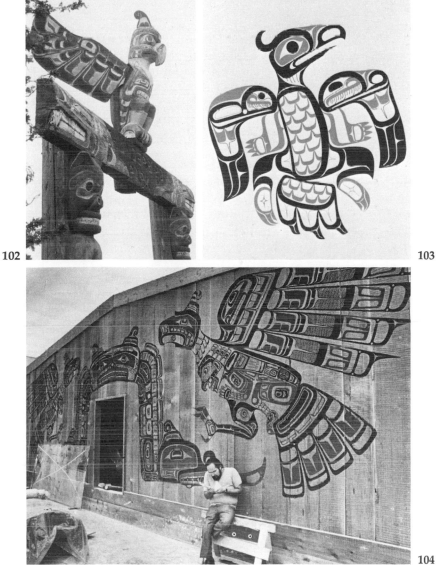

102 Kwagiutl Thunderbird in Thunderbird Park, Victoria, B.C., carved by the late Mungo Martin. It is the last carving that the renowned artist completed before his death in 1962 at the age of eighty-three.

103 Joe David's *Thunderbird Dancer* represents a dancer with his hands holding out the blanket to display to the audience his crest on the back. (West Coast)

104 Kwagiutl plank and beam house under contruction (1975) in the British Columbia Provincial Museum, Victoria, has a *Sisiutl* guarding the entrance, with a highly decorative *Thunderbird* on each side; both are Tony Hunt designs. In the foreground, Haida artist Francis Williams is carving a small grease dish.

Frog

Until they were introduced recently, there were no frogs inhabiting the Queen Charlotte Islands, and legend explains why. When the Frog chief first encountered a black bear, he was terrified, particularly when the huge animal tried to step on the hopping creature for fun. The frog escaped, returned to his village, and related his frightening experience. Fearful that the bear would seek them out, the frogs decided to flee the islands.

The Haida are said to have carved a frog on a house pole to prevent it from falling over, and it was their belief that Raven ate frogs. North of the Queen Charlotte Islands, the Tlingit record in legend the distribution of frogs over their land. A chief's daughter made fun of a frog and was later lured into the lake by a frog in human form, whom she subsequently married. Unable to persuade the Frog People to let her return home, her parents dug a ditch and drained the lake, scattering frogs in every direction.

In flat design the frog may be depicted from above or from the side; in three-dimensional carving it readily lends itself to the form of a bowl. Some of the most impressive tobacco mortars of the north have been sculptured from stone to represent a frog, and many wooden grease dishes were carved in this image.

Frog's characteristics are a large mouth, usually thick-lipped, and legs, with toed feet, in a flexed position. The absence of teeth, ears and tail confirms its identity.

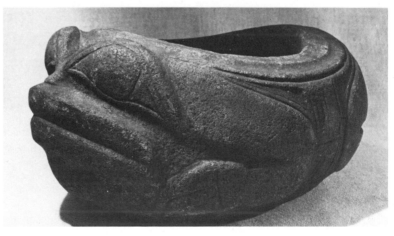

105

105 A tobacco mortar carved from stone in the shape of a plump frog breathes the very essence of this amphibian. National Museum of Man, Ottawa. (Haida)

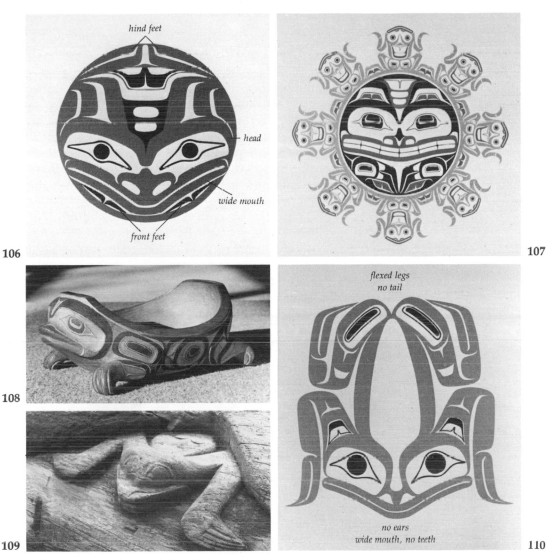

106

107

108

109

110

106 *Frog* by Robert Davidson is designed to fill a circular shape. The front feet have been moved to above the head; the hind feet, placed at the top of the circle, are minimal. (Haida)

107 *Frog People Fleeing from Black Bear*, an unusual design by Don Yeomans, illustrates a legend explaining why there used to be no frogs on the Queen Charlotte Islands. (Haida)

108 An elegant frog bowl probably made by the famed Charles Edenshaw of Old Masset, Queen Charlotte Islands. Museum of Anthropology, University of British Columbia. (Haida)

109 Detail from a fallen pole at Ninstints in the Queen Charlotte Islands. A frog is seen emerging from beneath the tail of a whale. (Haida)

110 Defined by a red form line, Robert Davidson's *Frog* is in the simple, classic style of northern art. (Haida)

Sisiutl

A dramatic mythical creature frequently portrayed by Kwagiutl artists is the Sisiutl, a two-headed sea serpent. This supernatural being could transform itself into many things, including a self-moving canoe which the owner would have to feed with seals. The Sisiutl killed and ate the flesh of anyone who saw it, and washing in its blood turned a person to stone. Legend tells of a man's hands becoming petrified this way.

Awesome Sisiutl guarded the entrance to the houses of supernatural creatures, and so was sometimes painted over the doorways of people's houses for protection.

Sisiutl is always portrayed with a face in the centre of its body, the two ends of the snake extending out from the sides of the face or curling around to form a circle. The profile head on each end, and the one in the centre, have curled horn-like appendages like Thunderbird's. Large round nostrils, teeth with pointed canines, and a long protruding tongue complete the serpent heads. Where Sisiutl forms a circular design, another motif usually fills the centre space.

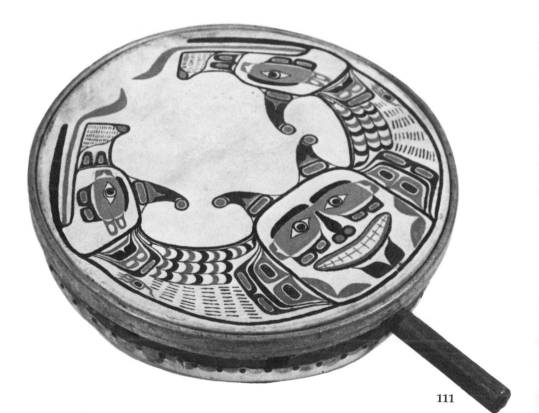

111

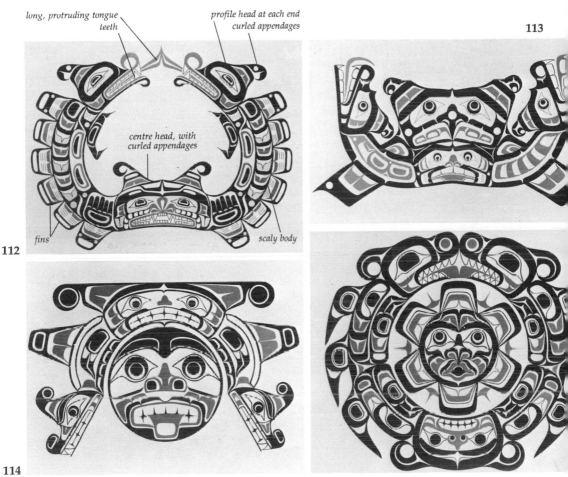

long, protruding tongue
teeth
profile head at each end
curled appendages

113

centre head, with
curled appendages

fins
scaly body

112

114

115

111 Kwagiutl two-sided drum, with Thunderbird on the underside. The upper face shows a Sisiutl design fitting well to the circular shape. Colours are black, red, blue-green and green; circumference 42 cm (15½ inches). Vancouver Centennial Museum.

112 The two sides of *Sisiutl* by Richard Hunt curve up to form an arch; the face in the centre of the body has human hands. (Kwagiutl)

113 *Sisiutl* by Larry Rosso has the sea serpent's two heads spread apart. (Kwagiutl)

114 Amos Dawson brings the heads of *Sisiutl* down around a central moon design. (Kwagiutl)

115 The sea serpents in Beau Dick's *Sisiutl* meet to form a tight circle around a sun design. (Kwagiutl)

Salmon

The Tsimshian said that the Salmon People lived in five different villages in the sea, with the spring salmon on the far edge of the ocean. In early spring, they changed from human into salmon form and started on their journey across the ocean and up the Skeena River, alerting the people of the other villages, who promised to follow at different times. The coho always said they would wait until late fall.

The five species of salmon were, and in some measure still are, a vitally important food resource to almost all the people of the Northwest Coast, and there are many legends telling how they were brought into the sea, rivers and lakes. In one way or another, this was usually the work of Raven or of a supernatural creature who was his counterpart.

Contemporary graphic artists have created salmon designs more elaborate and decorative than those of previous times. These attractive fish motifs have appeared in a variety of ways, including a silkscreen design on T shirts and a ten-meter (34-foot) mural on a downtown business building.

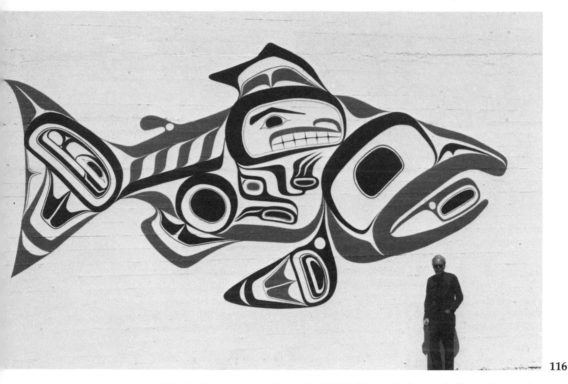

116

116 Artist, carver and jeweller Bill Reid stands beneath the wall painting of his Haida Dog Salmon design, Vancouver, B.C.

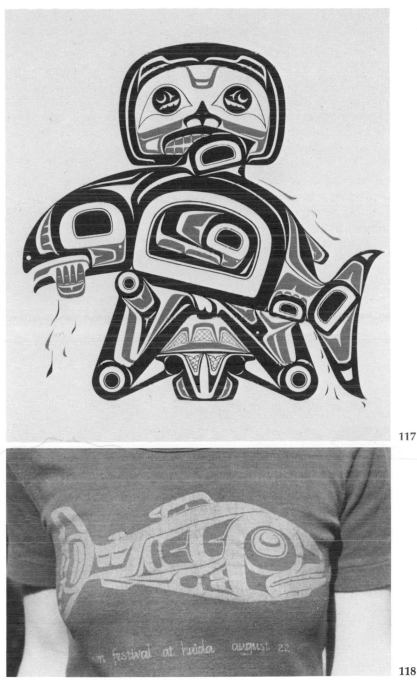

117

118

117 Neil Sterritt's *The Arrival of the First Spring Salmon* depicts a fisherman traditionally honouring the first catch of the season. ('Ksan)
118 *Salmon* T-shirt designed and printed by Robert Davidson in Haida (Old Masset), Queen Charlotte Islands.

Dogfish or Shark

In early times the dogfish crest was applied to a wide range of utilitarian items as well as ceremonial clothing and regalia. The labret, a lip ornament, is sometimes shown in a dogfish design to indicate that the fish is a woman. In the north this representation is a reminder of the woman who was carried off by a dogfish and became one of its kind.

Easy to identify, Dogfish always has a high domed head, a downturned mouth—usually with sharply pointed teeth—and gill slits on each side of the mouth. The high "forehead" is the underside view of the fish's long tapering head and nose.

Other identifying features of this member of the shark family may include:

> two small round nostrils
> gill slits on the forehead and/or cheeks
> eyes having vertical pupils
> prominent fins
> sharp spines
> asymmetrical tail flukes.

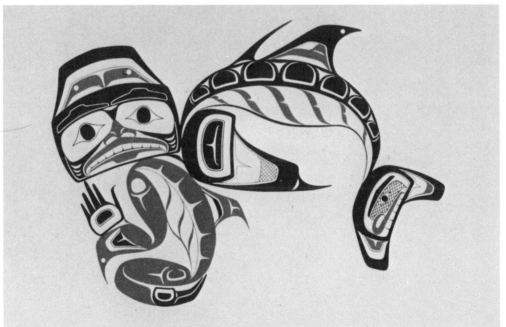

119

119 *Dogfish and Spirit* by Norman Tait, Nishga artist from the Nass River. The spirit of the fish is depicted together with its physical body; the two share one head, the spirit having human attributes of eyebrows and hand.

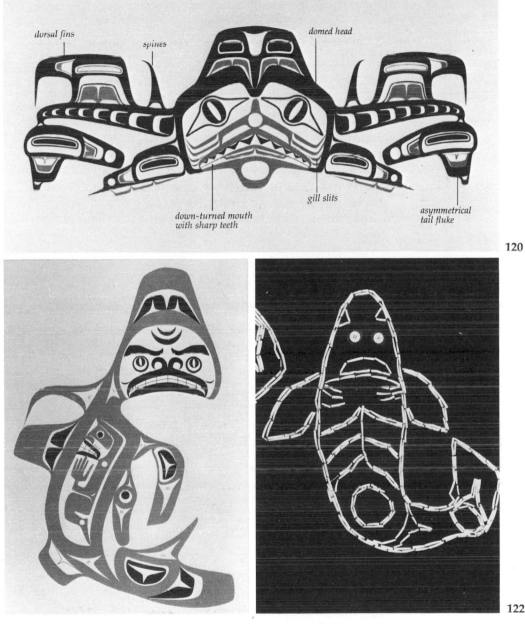

dorsul fins

spines

domed head

gill slits

down-turned mouth
with sharp teeth

asymmetrical
tail fluke

120

121

122

120 Robert Davidson's *Dogfish* is a good example of the split figure, and the labret in the lower lip is prominent. (Haida)

121 Art Thompson's *Dogfish* depicts a human form within the body. (West Coast)

122 The shark design on an old woollen dance shirt is outlined in dentalia (tusk shell), but the eyes are buttons. Rasmussen Collection, Portland Art Museum, Portland, Oregon. (Tlingit)

Halibut

To the Nimpkish tribe of the Kwagiutl, on Vancouver Island, it was Halibut who, stranded at the mouth of the Nimpkish River when the great flood subsided, threw off his skin, his tail and his fins to emerge as the first man.

But the Tlingit credit the halibut with giving the Queen Charlotte Islands their present form. They say a fisherman caught a small halibut which his wife, in disgust, threw out onto the beach, but it began growing and flopping about, getting larger and more violent. Finally its enormous size caused it to smash the single large island into two, creating smaller islands and scattering the people over the land.

The halibut is a flat fish that starts life swimming in a vertical plane but, as it matures, turns over on its side and becomes a bottom feeder. The underneath eye then migrates to the upper side, giving the fish its odd looking face with mouth to one side and eyes off-centre.

These features, together with the spread-out tail and oval body shape edged with a fin, are the identifying marks of the halibut. Never distorted to fill a given shape, the characteristic body contour is often used by carvers in creating bowl designs.

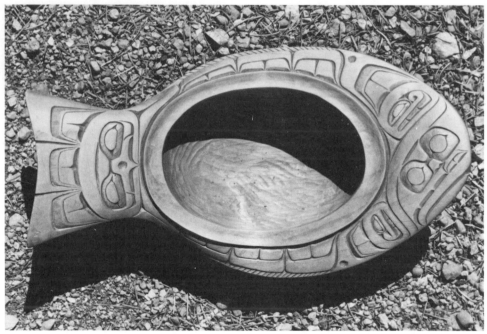

123

123 Halibut bowl owned and frequently used by Joy Inglis, Quadra Island. Carved by Larry Rosso. (Kwagiutl)

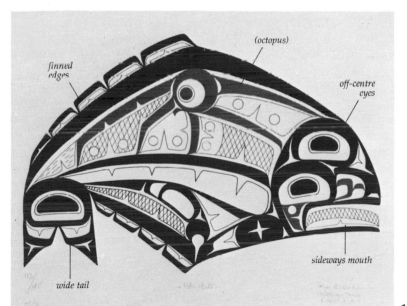

124

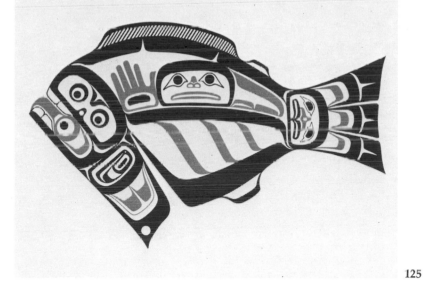

125

124 Roy Vickers's design of *Halibut* shows an octopus in the body cavity. A favoured food of this fish, octopus was used to bait the wooden hooks of early days. Five tentacles radiate from the round body, and small circles represent the suckers. (Kwagiutl)

125 *Halibut* by Larry Rosso has a decorative pectoral fin and a human representation on one side of the body—a reminder that the first Nimpkish people originated with this fish. Three lines on the other side indicate ribs. (Kwagiutl)

Red Snapper

One of the few colourful fishes of northwest coastal waters is the red snapper, a formidable looking rock fish of brilliant hue.

The fish received its bright colour, according to a Tlingit legend, when a man went looking for his wife, whom the killer whales had abducted. He lifted up the edge of the sea as though it were a blanket, and walked under. As he journeyed on, he came across some very pale looking fish, and, wishing to please them, he painted them all red. And the fish have been red ever since.

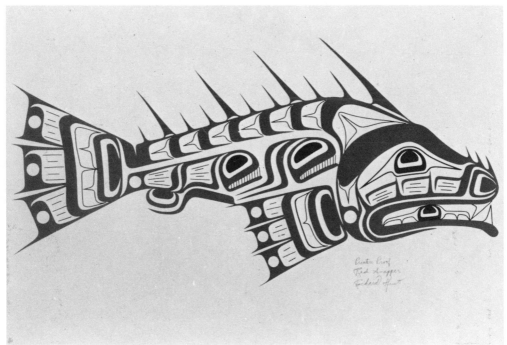

126

126 The formidable-looking *Red Snapper* has a large mouth with tongue and teeth, and an array of dorsal spines. This print, almost entirely in red, is by Richard Hunt. (Kwagiutl)

127 Recognized by its top-heavy proportions, *Bullhead* by Earl Muldoe also has the spiny fins characteristic of this fish. ('Ksan)

Bullhead

A Tsimshian legend documents how the bullhead acquired its top-heavy body. Raven grabbed it from the river, but the slippery fish escaped his grasp. The hungry bird made another snatch and this time he squeezed the bullhead so tightly that its innards squished into the upper part of its body, causing its eyes to bulge. Although, with great effort, the fish managed to escape back to the river, all bullheads have retained that bulging shape ever since.

The large upper body and the spines typify the bullhead, a motif not often seen in design.

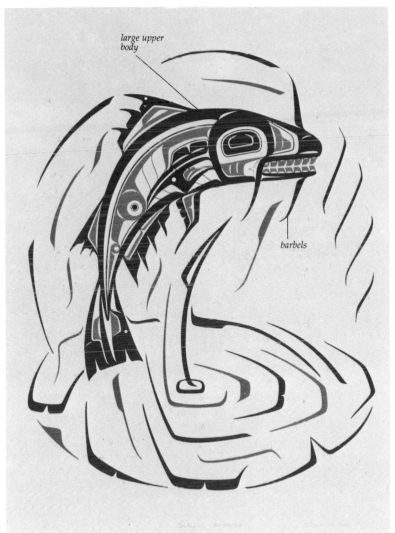

127

Sea Monster

Nearly every culture has its version of the Loch Ness monster, and it is only natural that the Northwest Coast Indians—imaginative peoples who held strong beliefs and lived closely with the sea—should have had their mythical but believable sea monsters also.

Sea monsters took various forms and had different names, but frequently they were a whale-wolf combination and thus had coiled tails, clawed feet, and flippers.

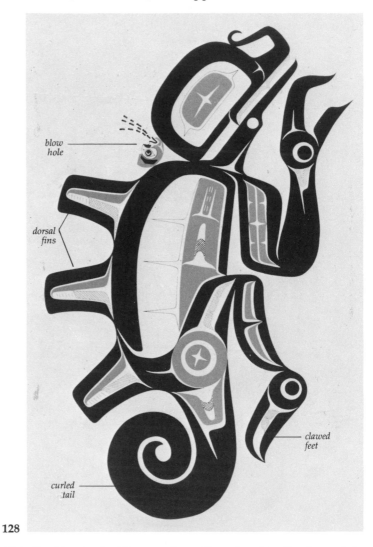

blow hole

dorsal fins

clawed feet

curled tail

128

128 This *Sea Monster* by Hupquatchew, Opetchesaht tribe, has whale associations through its dorsal fins and blow hole. (West Coast)

Mosquito

Occasionally a mosquito may be seen carved on a totem pole, the long proboscis generally being its main symbol of identification.

This pesky insect was once quite large, in fact human size, according to Tsimshian legend. In the story a woman whose child was killed by a blood-sucking mosquito hid on the branch of a tree overhanging a lake. The chief of the mosquitos came to the lake, but saw only her reflection. Enraged when she made fun of his long nose of crystal, he dove at her image in the water, and when he came ashore North Wind froze him to death. After burning his body the woman blew into the fire, causing ashes to fly up and turn into thousands of small mosquitos. And to this day they are still small, but they retain their blood-sucking habits.

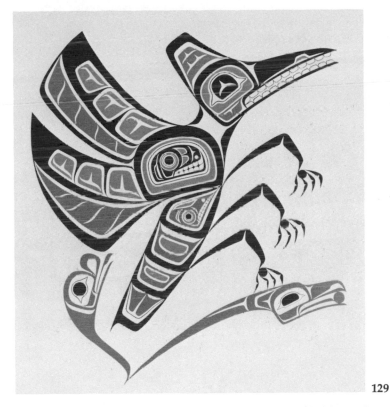

129

129 *Mosquito* by Walter Harris has a toothed and beak-like proboscis with double wings and an insect's body and legs. A small mosquito head is portrayed in the body being consumed by the flames. One flame is seen as Raven with fire in his beak, since it was Raven who originally brought fire to the people. ('Ksan)

Sun

At one time all the world was in darkness because a powerful chief kept the sun hidden in a box. It was cunning Raven who, by trickery, stole the sun from the chief's house, made his escape through the smoke hole, and flew with it into the sky. The proof of this story is, of course, the sun which is still shining there to this very day.

The Kwagiutl and Tsimshian saw the sky as a beautiful open country where the house of the Sun chief was located. By climbing up a chain of arrows, the traveller could reach it through a hole in the western horizon and could then return to earth by sliding back down on the long rays of the sun.

A face in the centre of the sun design, surrounded by rays which may be simple or elaborate, makes this symbol an easy one to recognize. The sun is a popular design motif of the Kwagiutl, and a large one stands atop the tallest totem pole in the world, at Alert Bay. Kwagiutl sun designs tend to be dramatic, with lengthy and highly decorative rays.

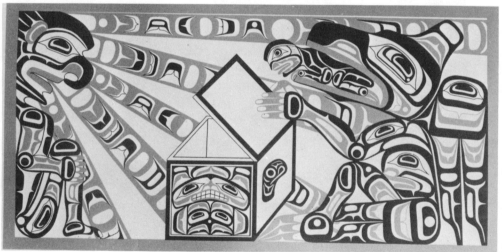

130

130 *Raven Releasing the Sun* by Calvin Hunt shows Raven holding the box lid open; the sun, in human form, sends out long, decorative rays of light. (Kwagiutl)

131 *Sun* by Larry Rosso has bold light rays reaching out. (Kwagiutl)

132 Tony Hunt depicts a bright *Sun* with sixteen rays emanating from it. (Kwagiutl)

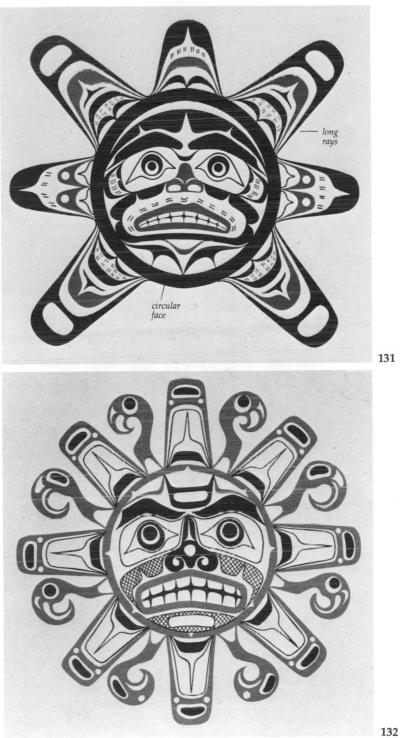

long
rays

circular
face

131

132

Moon

As well as stealing the sun to bring daylight, Raven stole the moon, along with all the stars, and these he flung into the sky to lighten the darkness of the night.

When there was an eclipse of the moon, the Kwagiutl thought that a codfish, with its great gaping mouth, was trying to swallow the moon. To prevent this happening, a large bonfire was lit and green boughs added to create a huge pall of smoke. As people danced ceremonially around the fire, thick smoke rose up into the sky, unfailingly causing the codfish to cough and spit out the moon. Equally successful were the efforts of the people who, on seeing the moon appear at the edge of a mountain, struck their drums or beat on a log with sticks to "drum up the moon."

The moon is portrayed much like the sun, with a face filling the centre, but no rays issue from it. Occasionally it may be shown in crescent form.

Among the Haida, Moon was the exclusive crest of only a few of the highest ranking chiefs.

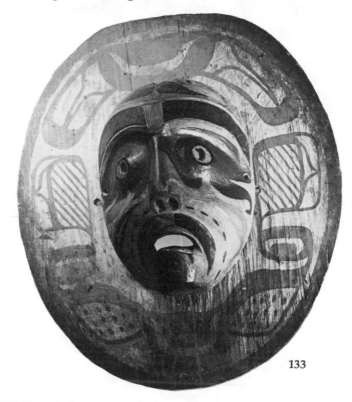

133

133 Kwagiutl moon mask. Museum of Anthropology, University of British Columbia.

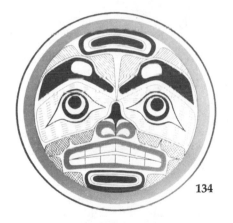

134

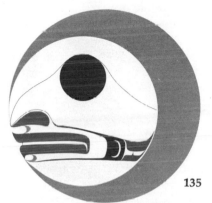

135

136

134 *Moon* by Tony Hunt shows a circular full moon with a woman's face. Hatching, crosshatching and dashes fill the open areas. (Kwagiutl)

135 *New Moon Spirit* by West Coast artist Frank Charlie owes its young look to an open, simple design.

136 Robert Davidson's *Moon* is an unusual version: a crescent moon with the profile of a man's face, his hand also forming the mouth. (Haida)

Box Designs

Some of the carved and painted bentwood boxes and storage chests of the Northwest Coast Indians rank among the most elaborate and beautiful of all their possessions. Many have a distinct front and back, with the forepart of the figure on the front and the hindquarters on the back. More complex than most of the usual crest figures, these designs follow a structured format: the upper half of the box front portrays a large head, with ears in the corners, the body filling the centre section and the front legs (or arms and hands) at each side. The remainder of the figure is often continued on the reverse side, showing the tail and hind legs with large ovoids for hip joints.

If the figure is complete on each side, then the lower or hind legs are minimal and tightly flexed at the base of the design, with hip joints filling the lower corners.

The eyes are generally the feature which distinguishes the front from the back. If present, the double-eye form indicates the head of the figure, which is the front of the box; the single eye form is on the back.

Occasionally the axis of the design is centred on one corner of the box, in which case the motif angles back to cover two sides, making a complex overall layout.

It may be significant that no particular crest figures are discernible on most of the old chests and boxes of the past. The late Prof. Wilson Duff, who paid particular attention to these boxes, suggested a reason: only an ambiguous design would enable a box to be traded along the coast, since a man could not use a crest that he neither owned nor had a right to display.

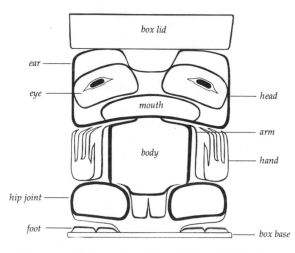

Schematic diagram of the printed box design (139) shown opposite.

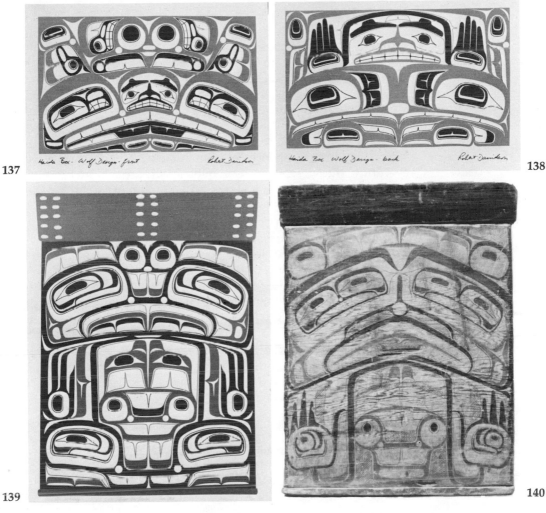

137 Haida Box. Wolf Design - front Robert Davidson

138 Haida Box Wolf Design - back Robert Davidson

139

140

137, 138 Two early prints by Robert Davidson are designs for the front and back of a box. They represent a wolf. The box front (137) depicts a wolf's head with long ears sweeping up to the corners; between are filler elements. The back of the box (138) shows the wolf's body represented as human; beneath are large ovoid hip joints with the leg and clawed feet below. (Haida)

139 A silkscreen print of a painted bentwood box with its lid, copied from a Tlingit box made around 1850. Print by Vin Rickard.

140 Tlingit storage box in the Rasmussen Collection, Portland Art Museum, Portland, Oregon. The front of the box has double-eye motifs in a large head filling half the space. Human hands below have salmon-trout heads on the palms.

Human

Although wood carvings may feature entire human figures, flat painted designs until recently depicted people in a minimal or very stylized way. Such human representations were often fragmentary, showing simply the face, or a face with hands, as in a transformation image. To bring the old legends to life, contemporary print makers are, in some regions, creating a new tradition by featuring people as the subject matter.

In northern art, the faces of humans usually carry distinctive eyebrows, the eyes are not set in ovoids, ears are seldom present, and often a human hand is shown. A labret (lip ornament) in the lower lip identifies the person as a woman.

Two or three human figures wearing high hats, perched on the top of Haida poles, are watchmen. The watchmen on the house of a supernatural being, legend says, alerted its owner to the approach of an enemy or to any other incident he should know of. The segments, called rings, of the hat's high crown signify wealth and rank. Each ring denotes a potlatch given by the wearer or his ancestor; therefore the more rings, the more important the owner.

A simplified representation of these "rank rings" can sometimes be seen between the ears of a bear or beaver crest. In the form of a vertical element containing several ovals or divisions, it indicates that the crest belongs to a high ranking family.

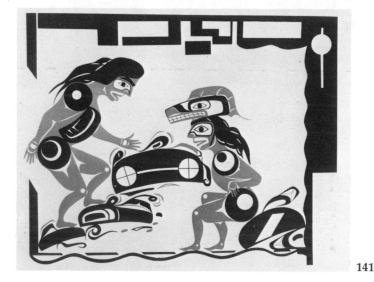

141

141 Lifelike humans are depicted in Tim Paul's West Coast legend illustration entitled *Earthquake Foot*. The figure on the right wears a wolf mask on his head.

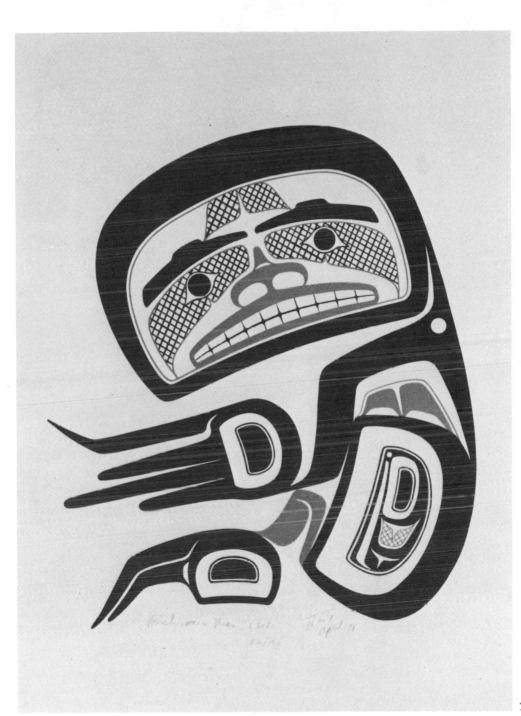

142 *Mischievous Man, Tsek.* Nishga artist Norman Tait characterizes the legendary culture hero of his people by portraying him as part spirit, part human.

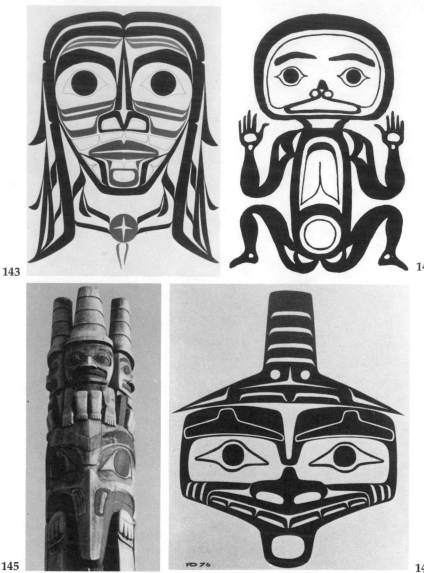

143 *Tsimshian Woman* is an unusual portrait by Roy Vickers. The small ovoid in the lower lip represents a labret. ('Ksan)

144 A human figure, one of four on an early Tsimshian screen painted to represent a dragonfly.

145 Three watchmen on the top of a pole carved by Bill Reid wear segmented high-crowned hats to denote rank; they top the frontal pole of the reconstructed Haida house at the Museum of Anthropology, University of British Columbia. (Haida)

146 Entitled *Transformation*, this image by Robert Davidson was designed for the inside of a fold-out card. It portrays a woman of rank, symbolized by the ringed hat and labret. (Haida)

6 / Cultural Styles

First contact with the art of Northwest Coast Indians may leave the impression that it all looks similar. The more one studies it, the greater one's awareness of the distinctive style that belongs to each cultural group.

Over the centuries, through travelling, trading, and the acquisition of slaves, the various art styles have influenced each other in diverse ways. Many crests and legends recurred along the coast with tribal variations, and there was much in common among the art traditions of nearly all the peoples of the Northwest Coast. In spite of this common basis, many well developed stylistic traits remained within certain boundaries.

The following is a brief look at the main characteristics of regional styles, with emphasis on silkscreen prints. Contemporary works clearly indicate that the future will bring new directions, perhaps even more than in the past, but individuality will always remain, both among artists and their cultural regions.

Coast Salish

Totem poles, monuments declaring the crests and lineage of important families, were not a part of the Coast Salish culture. Not having a crest system, Salish artists made less use than did other coast peoples of painted embellishments.

Although the only people on the Northwest Coast not to have totemic poles, the Coast Salish were imaginative artists with an ancient woodworking tradition. Carved animal figures, in a somewhat realistic style, embellished the house posts of their large communal houses, and life-like human figures stood as grave markers. Some of the finest Salish art is seen on the spindle whorl, a disc which acted as a flywheel on the spinning device used for making wool yarn. Many large whorls were carved with intricate designs on both sides. Superb blankets of mountain goat wool were woven from the yarn on a two-bar loom, the upright posts of which were often decoratively carved.

The only ceremonial mask used by the Coast Salish, the Sxwaixwe mask, was of elaborate form in three dimensions. Shamans' rattles made from mountain sheep horn carried deeply incised designs, as did bowls shaped from this material. Combs and spoons were carefully carved in wood. Canoes were sleek

craft hewn from a single log; the making of these hulls for inter-tribal racing events is a continuing art, although the elegant design has been considerably changed for greater speed.

A few carvers are making bowls and plaques for wall hangings, and some of the older women are still producing excellent basketry with traditional designs imbricated with cherry bark. The art of weaving the famous Coast Salish wool blankets on the ancient two-bar loom has long been re-established in the Fraser valley, where the wool is hand spun and dyed with natural dyes.

Traditionally, these southern people made much less use of the painted two-dimensional art so loved by the people of the north, and this may account for the small quantity and late appearance on the market of Coast Salish art in graphic form. A few carvers on Vancouver Island are reproducing impressive spindle whorls, and incorporating designs from them in their carvings. There seems to be strong evidence that the unique style of this Salish art is again taking its prideful place on the Northwest Coast.

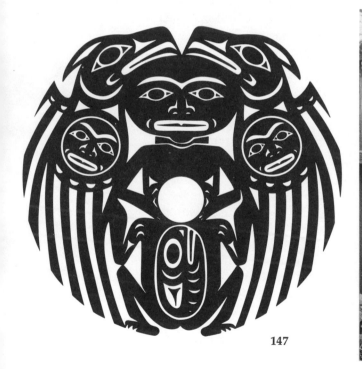

147

148

147 Spindle Whorl Design—Human with Thunderbirds. Stan Greene has taken the motif of an old carved wood spindle whorl, of the type used by Salish women to spin wool, to create a strong one-colour print.

148 A Coast Salish grave figure, carved in wood, shows a man holding an animal.

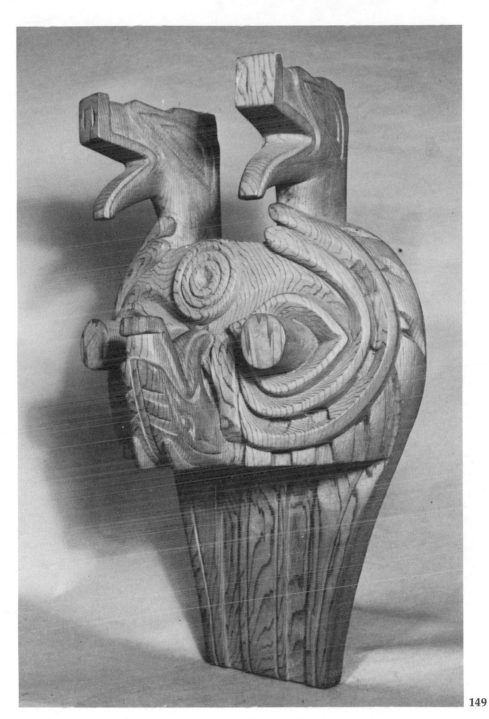

149 The only mask used in ceremony by the Coast Salish is the Sxwaixwe mask, a large elaborately carved item. Museum of Anthropology, University of British Columbia.

West Coast (formerly "Nootka")

For two centuries the several different Indian tribes inhabiting most of the west coast of Vancouver Island have collectively been called Nootka. The name, imposed upon them by Capt. James Cook through a misunderstanding, has been perpetuated by historians and anthropologists, but it has always been resented by the people themselves. The artists and carvers among them have re-established their traditional art and have imaginatively developed it into a distinct style. Their work has earned them prominence in the ever widening panorama of Northwest Coast art, and thus brought about frequent reference to their outer coast nation. Although a well established name is not easily changed, in this third century after Cook it seems fitting to abandon the ill-conceived label "Nootka" and to respect the integrity and pride of the Indians by referring to them in the way they refer to themselves: as West Coast people. Written as two separate words, both capitalized, the name is easy to distinguish from the more general "Northwest Coast."

The art of the West Coast people has a flowing and flexible look often combined with angularity. Form lines are fluid with no tight control, or are nonexistent; they seldom compress a design into a given shape but rather allow it to float freely against the background, though a border may surround it. The art uses very few ovoids. When northern influences do not creep in, ovoids are elongated with rounded ends, as are the U forms, both lacking the tautness of their northern counterpart. Also absent is the northern propensity to filling blank areas or open spaces with elements of design.

Particularly characteristic are the squared and rectangular shapes which represent clouds, sea, rocks and other elements and which often form a border. They come as a surprise to someone seeing them for the first time, but such geometric shapes date back to earlier art works and may have been influenced by basketry designs.

The use of the "four way split" also comes from the past. It originated as two split U forms put together, and is sometimes stylized simply as a cross within a circle. Lines composed of dashes, or parallel dashes, are also traditional, as are circular elements and curlicues.

The human face in profile having a dominant, aquiline nose and large mouth is sometimes seen in West Coast prints. These often represent masked faces and are derived from West Coast dance masks, which are made to be seen from the side, the dancer keeping his head turned to one side or the other to maintain the

150

profile to the audience. Unmasked human heads often show face painting, a stripe of colour across the face. Incorporating a small human head into the body of a bird or animal is a reminder of the creature's supernatural powers that enable it to transform into, and out of, human form at will.

It was characteristic of the people to use any new material to their advantage, including the newcomers' pigments, and by the early twentieth century they were successfully incorporating even silver and gold paint into carvings. This practice has been extended into modern times with the use of bright colours in silkscreen prints.

Some West Coast print makers, responding to the freedom of their art tradition, have used it to illustrate the powerful legends of their people; these artists create intriguing prints which can only be fully enjoyed by knowing the story depicted. Some bring new and different ideas to the art, giving it a fresh liveliness.

Because many of the artists choose to work and live away from the distractions of the big cities, they are finding opportunity to re-establish and re-affirm the worthwhile aspects of their ancient culture which lead to ceremonies involving dancing, singing and potlatching. These events are the traditional impetus for the making of painted dance screens, drums, rattles and other regalia, and by participating in them physically, the artists experience the cultural and spiritual as well as the aesthetic value of their work.

West Coast art is a vigorous and distinctive art that is moving in new directions while keeping strongly in touch with its past. For those accustomed to the more classic northern art style, such as the Haida, it can open new doors of appreciation and add considerably to the enjoyment of the art of the Northwest Coast Indians.

150, 151 Painted paddles from the West Coast. Contemporary artists continue to use the rounded ovoids and U forms and the characteristic eye shape of this art style.

151

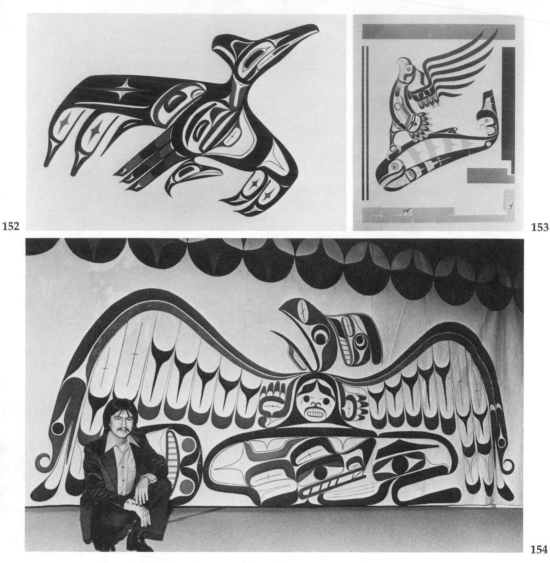

152 *Raven*, by Tim Paul, shows the four-way split in its two forms: as a pair of back-to-back split U forms, and stylized as a cross. (West Coast)

153 *Kwatyaht's Gift to Ťeetskin* illustrates a legend in which a powerful being, dressed in a whale skin, dives beneath the sea to drown Thunderbirds as they grasp him with their talons. Flowing lines, lack of structural ovoids and a sharp-nosed mask at the whale's tail, together with a geometric border, place this design—by Hupquatchew of the Opetchesaht tribe—in the West Coast stylistic tradition.

154 Joe David's dance screen, used by him for dances, portrays Thunderbird and Whale, with Lightning Snakes outlining the upper edges of the wings. U forms are rounded; ovoids are few and also rounded without tautness. Open spaces are left undecorated, and four-way splits are prominent. (West Coast)

96

Kwagiutl

Extravagant and complex masks, flamboyant totem poles topped by thunderbirds with great outstretched wings, and even the tallest totem pole in the world: all are creations of Kwagiutl artists.

Known for the magnificence of their elaborate Winter Dance Ceremonies, the Kwagiutl have a dramatic flair that is reflected in their silkscreen prints. Birds are poised for flight, the Sisiutl writhes and undulates, and the sun emanates long, embellished rays. To accentuate this movement, the designs are generally composed of many small elements rather than large units. Variations of the U form, the split U and dash lines are all used in repetition for a decorative effect that conveys a busy, active feeling.

Body proportions of both human and animal subjects are not greatly exaggerated or distorted, and realistic feathers are often depicted on a bird's body. The shape of the eye socket ovoid is often irregular; eyelids are long and pointed on either side of the eyeball. These characteristics are particularly noticeable in wood carving, where eye sockets are deeply sunken and eyeballs are prominent, as are cheek bones.

Kwagiutl carvings tend to have a strong, bold look with deep cut areas which in totem poles transform much of the cylindrical contour of the log and produce a more three-dimensional sculpture, often with numerous attachments, such as beaks, fins, and wings. Face masks are robust, with features emphasized by painting, and supernatural bird masks are often wildly inventive

155

155 A painted grave marker at Alert Bay depicts the whale crest, and may represent a two-finned killer whale. (Kwagiutl)

and elaborate; some have enormous beaks that open and close during dances, or—to symbolize transformation—an outer mask that opens to reveal an inner mask.

Combined with other colours, black is used extensively for outlines on crest figures, both on carved and two-dimensional works of art. The characteristic use of many different colours occurs in many renderings by Kwagiutl artists, whose ancestors were quick to make use of commerical paints on early totem poles. This love of traditional colour, basically black, red, green, white and sometimes yellow, shows in many silkscreen prints and on carvings.

For silkscreen prints, Kwagiutl artists mostly prefer to stay within the traditional style of their crest art, seldom leaving it for unconventional experiments. The Thunderbird is important and frequently used in design, as is the Sisiutl (the double-headed sea serpent), the latter perhaps typifying Kwagiutl art more than any other creature.

The Kwagiutl of Alert Bay, a village on a small island between Vancouver Island and the mainland, were among the first to construct a traditional plank house and integrate its use into village life. The people have been greatly involved in reviving the ancient songs and dances, and in recreating costumes, masks and ceremonial regalia when potlatches, feasts and other functions are celebrated.

Their dancers, beautifully costumed and equipped, give powerful and vivid expression to the deep spiritual meaning of these occasions.

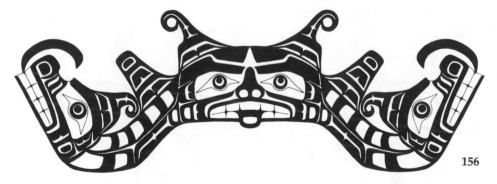

156

156 In Russell Smith's design of *Sisiutl*, the eyelids are typically long and pointed. (Kwagiutl)

157 *Hok-hok*, by Tony Hunt, is the cannibal bird said to have cracked open human skulls to eat the brains. The design is typically Kwagiutl in concept and style, with multiple U forms and split Us giving an elaborate decorative effect.

158 Also in decorative style, this dramatic *Crane* by Calvin Hunt has a body feathered with U forms. Dash lines are used liberally. (Kwagiutl)

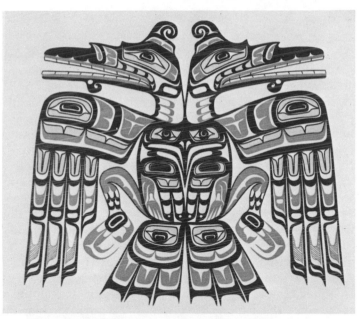

157

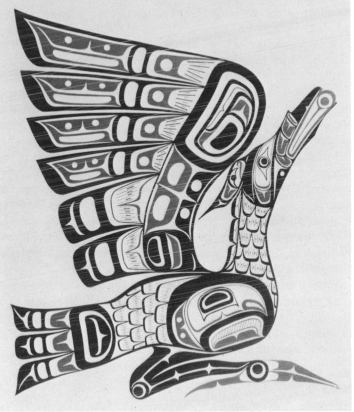

158

'Ksan

The replica of a Gitksan village on the upper reaches of the Skeena River, near Hazelton, British Columbia, has become the site of a major art centre for training Northwest Coast Indians in the design style and skills of their forefathers. The art of this new generation reflects a rebuilding of the old traditions and the emergence of a strong people with a vigorous sense of identity.

The village, called 'Ksan, houses an up-to-date silkscreening department where native artists do exceptionally fine work. Using traditional elements, many of the artists are illustrating the ancient legends of their people, and in so doing bring a strikingly fresh and innovative quality to the old art style. A strong school of art, stylistic as well as actual, has emerged among the Tsimshian, Gitksan and Nishga people (collectively called the Tsimshian by anthropologists), and it seems appropriate here to look at the 'Ksan style rather than try to define "Tsimshian" art.

Guided by instructors with a strong personal style, the artists have, since the late 1960s, developed a look to their diverse designs which is distinctly 'Ksan. With roots in its own tradition of precision and linear refinement, 'Ksan art is clean lined and crisp.

It is a positive art, personal and emotional, with clear and definite ideas expressed in two dimensions. Human figures are rendered in lifelike appearance, often in action or conveying some emotion, and are frequently interrelated with animals or inanimate objects. The elements of the art are traditional, but segments of U forms and split U forms are elongated or abbreviated to provide the artist with additional shapes to serve his requirements. A distinguishing characteristic among some of the 'Ksan artists is the use of these linear elements detached, or nearly so, from the main body of the design. The appearance of vigorous movement is often enhanced by such lines, which give a feeling of vibrancy. Ovoids are always in the classic style of northern art, and flowing form lines diminish at the point of junction. Colours used are the traditional red and black, and occasionally blue-green also.

Like the Kwagiutl in Alert Bay, the Gitksan have an accomplished group of dancers who have travelled to other parts of the country to perform. In 'Ksan they entertain a great many summer visitors, proudly demonstrating with their music, masks and costumes the richness of their ancient culture.

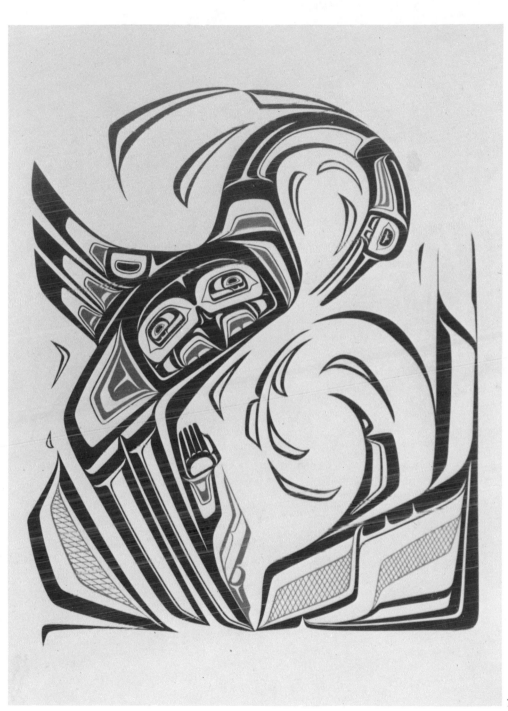

159 Illustrating a legend of his people, Ken Mowatt's *We-gyet and the Swans* includes linear elements detached from the main body of the design to portray vigorous motion. ('Ksan)

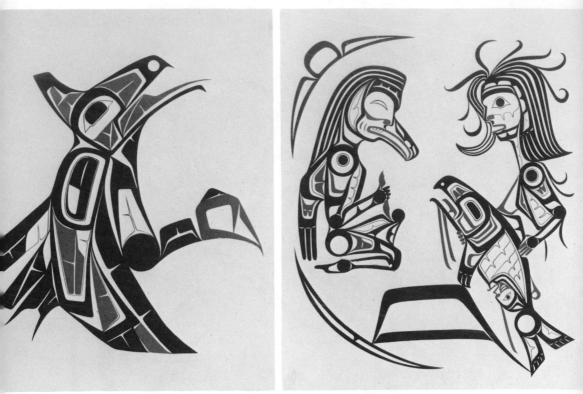

160

161

162

163

160 A design with a contemporary look, Robert Sebastian's *Raven* has the crisp, clean lines of 'Ksan art.

161 Like much of 'Ksan art, Art Sterritt's *We-gyet and the Bright Cloud Woman* is a personal expression of the Gitksan legend.

162 Using all the elements of the art, Vernon Stephens has created a fully attired warrior, including the traditional helmet and visor with its carved and painted designs. Title: *Gitksan Warrior, Quest for Land*. ('Ksan)

163 Vernon Stephens uses few traditionally stylized forms and adds a touch of realism to his work in this print entitled *Goo-nah-ne-sim-get-Races to Save His Wife*. Refined linear design is characteristic of the 'Ksan art style.

Haida

The words "monumental" and "classic" are often used in describing Haida art. The massive carved totem poles emanate a strength and a power that is echoed in miniature poles of argillite.

Because some authorities believe that Haida artists brought Northwest Coast art to its peak (some do not agree), and because it is the best known of the cultural styles, its bold, uncluttered look has become a standard. The purity of its forms, and the refined sense of balance that governs their use, show up in contemporary printed designs.

In Haida and northern art, ovoids follow classic proportions, and form lines, generally well defined, are flowing yet controlled and formal. Another northern distinction shows in body proportions. Often the head of a creature occupies nearly half the length of the figure, as though the head were the most important feature. This is particularly evident on totem poles, where eyes and eyebrows are large and the nose, mouth, tongue or beak emphatic, with the rest of the body in smaller proportion. In prints, as on poles, large ovoids are used as structural body parts; small ones contain faces for decoration in or between ears, in empty corners, or on wing and tail joints. Blank spaces are never left unadorned. Although a large design may be filled with larger elements, it retains a highly unified, structured look.

The colours black and red are adhered to by the Haida print makers, whose ancestors used these pigments exclusively. Although a few of the artists may deviate for the sake of experimentation, they always return to the black and red combination, a mark of the purity of this classic art. Contemporary Haida artists seldom depart far from their design traditions, and thus they have preserved a look that is clearly Haida.

Haida designers enjoy the organized balance that symmetry brings, especially to poles, and they often achieve it in their prints as well as in engraved bracelets of silver and gold, where the effect is often accomplished by the use of a split figure.

In recent years the islands of the Haida have witnessed two important pole raisings, the opening of two traditionally styled houses, and other ceremonial occasions, all requiring dancing with singing and drumming. One result has been a great proliferation of button blankets bearing family crests on the back. Many of these garments, navy blue with red appliqué and with thousands of buttons sewn on to define the crest, are intricate and beautifully designed. The button blanket has, in fact, blossomed into a distinctive art form and a new expression for two-dimensional crest art all along the coast.

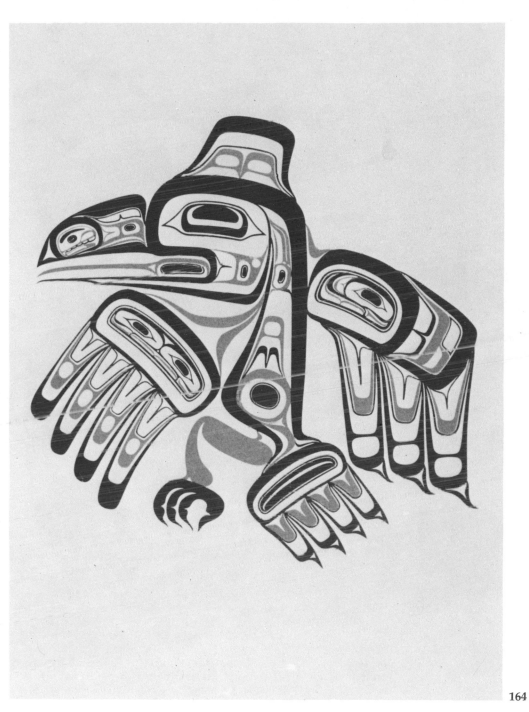

164 *Haida Raven* by Bill Reid carries all the hallmarks of the art of these northern island people. The form lines flow freely, and although asymmetrical, the design is balanced.

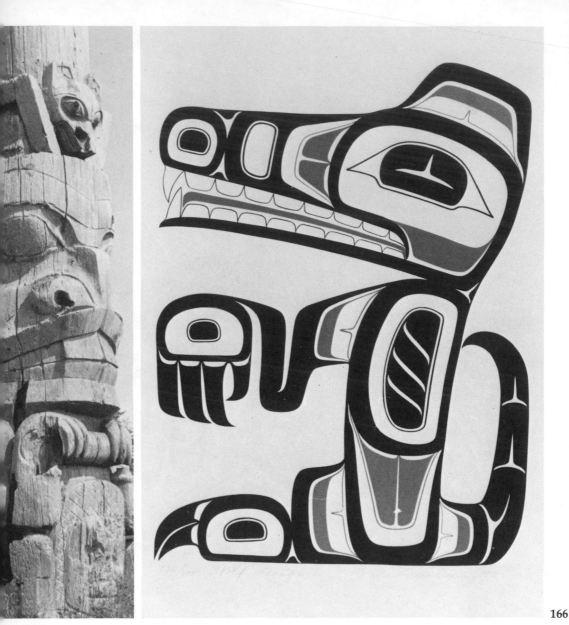

165 The last of the old poles at Skidegate, Queen Charlotte Islands, has a classic Haida beaver at its base.

166 *Haida Wolf* design by Freda Diesing brings together all the classic forms of Haida art; bold form line with finely tapering points, well defined U and split U forms, S forms, and a balanced distribution of red and black.

167 A copy (by Bill Reid) of a section of the famous four-part Raven screen of Hoonah, thought to be originally from Lituya Bay in Alaska. The similarity of painted Tlingit art to that of the Haida is evident.

Tlingit

Northern neighbours of the Haida, a people with whom they traded and had much in common, were the Tlingit of Alaska. Their art style, especially flat painted design, is similar to the Haida in many respects, and the art work of both is often referred to under the general term "the northern art style."

Presently only a few artists among the Tlingit work in silkscreen printing, and almost none of their work finds its way south.

The Tlingit were probably the first to reconstruct a community house in traditional style, complete with frontal painting and totem poles. During the depression of the 1930s, the United States government devised the project to provide work. Open to visitors, the plank house is also used for social and ceremonial functions by native people.

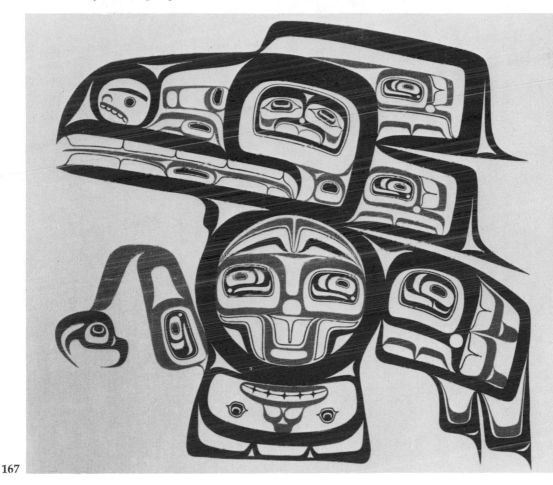

167

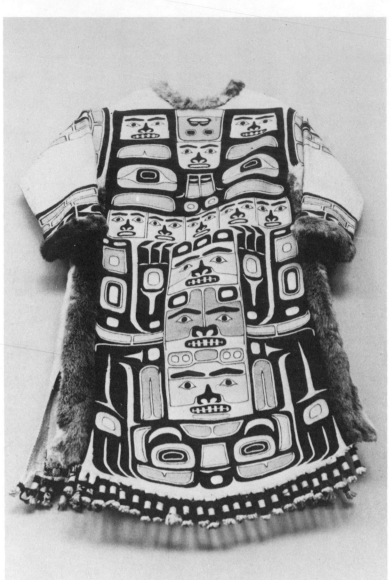

168

168 Ceremonial shirt of mountain goat wool and cedar bark made by the same technique as were the well-known Chilkat blankets (see example, page 36). Such garments represent a high point in the two-dimensional art of the Tlingit. In this bear design, the head and ears cross the chest, with a row of small heads forming the mouth and teeth. Two central faces, representing twin cubs, form the body, and two pairs of clawed limbs are at the sides. Rasmussen Collection, Portland Art Museum, Portland, Oregon.

169 Totem Bight Community House, near Ketchikan, Alaska, is painted to represent Raven. The large head (with double-eye motifs) fills most of the area; upturned wings are at each side. (Tlingit)

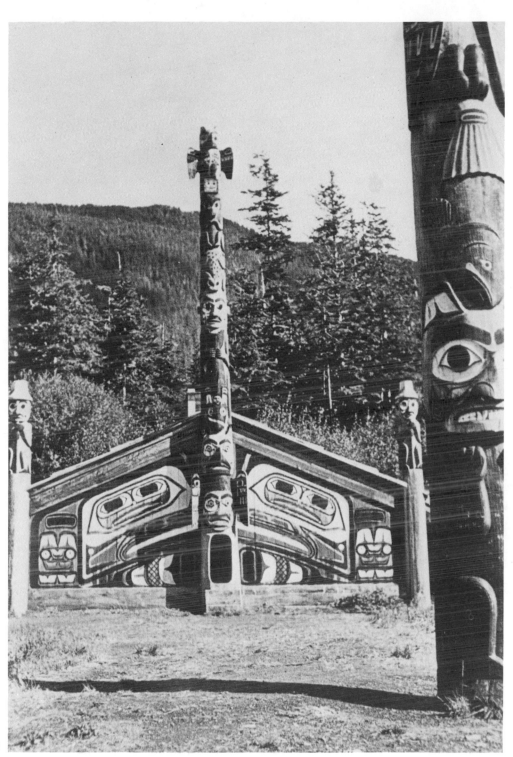

169

Bibliography

Boas, Franz and Hunt, George. *Kwakiutl Texts*. Second Series. Publications of the Jesup North Pacific Expedition, vol. 10. Leiden: E. E. Brill, 1906.

Boas, Franz. *Primitive Art*. New York: Dover Publications, Inc., 1955.

Drucker, Philip. "The Northern and Central Nootkan Tribes." *U.S. Bureau of American Ethnology, Bulletin 144*. Washington, D.C.: U.S. Bureau of American Ethnology, 1951.

First Annual Collection 'Ksan 1978 Original Graphics. Vancouver, B.C.: Children of the Raven Publishing Inc., 1978.

Garfield, Viola E. and Forrest, Linn A. *The Wolf and the Raven: Totem Poles of Southeastern Alaska*. Seattle: University of Washington Press, 1948.

Holm, Bill. *Northwest Coast Indian Art: An Analysis of Form*. Seattle: University of Washington Press, 1967.

Northwest Coast Indian Artists Guild 1977 Graphics Collection. Ottawa: Canadian Indian Marketing Services, 1977.

Northwest Coast Indian Artists Guild 1978 Graphics Collection. Ottawa: Canadian Indian Marketing Services, 1978.

Swanton, J.R. "Tlingit Myths and Texts." *U.S. Bureau of American Ethnology, Bulletin 29*. Washington, D.C.: U.S. Bureau of American Ethnology, 1905.

Swanton, J.R. "Contributions to the Ethnology of the Haida." *American Museum of Natural History Memoirs 5*. Part 1. New York: American Museum of Natural History, 1905.

Wingert, Paul S. *American Indian Sculpture, a Study of the Northwest Coast*. New York: J.J. Augustin Publishers, 1949.

Index of Artists

The numbers given are illustration numbers.